the

ARTFUL
SKETCH

Create Artistic Drawings Step by Step
to Embellish Your Home, Business, and Life

MARY PHAN

creator of Very Mary Inspired and
The Sketchbook Series

PAGE STREET
PUBLISHING CO.

PAGE STREET
PUBLISHING CO.

First published in 2018 by
Page Street Publishing Co.
27 Congress Street, Suite 105
Salem, MA 01970
www.pagestreetpublishing.com

Distributed by Macmillan, sales in Canada by The Canadian Manda Group.

Copic® is a registered trademark of .Too Corporation, which had no involvement in the creation or publication of this book.

22 21 20 19 18 1 2 3 4 5

ISBN-13: 978-1-62414-607-7
ISBN-10: 1-62414-607-4

Library of Congress Control: 2018934529

Cover design by Lucia Dinh Pador
Book design by Page Street Publishing Co.
Photography by Lane Dittoe
Illustrations by Mary Phan

Printed and bound in China

I dedicate this book to my immigrant parents,
for being my guiding light and showing me
what true bravery means. To my husband,
Chris, and my two sons, Noah and Elijah—
you are my daily inspiration.

CONTENTS

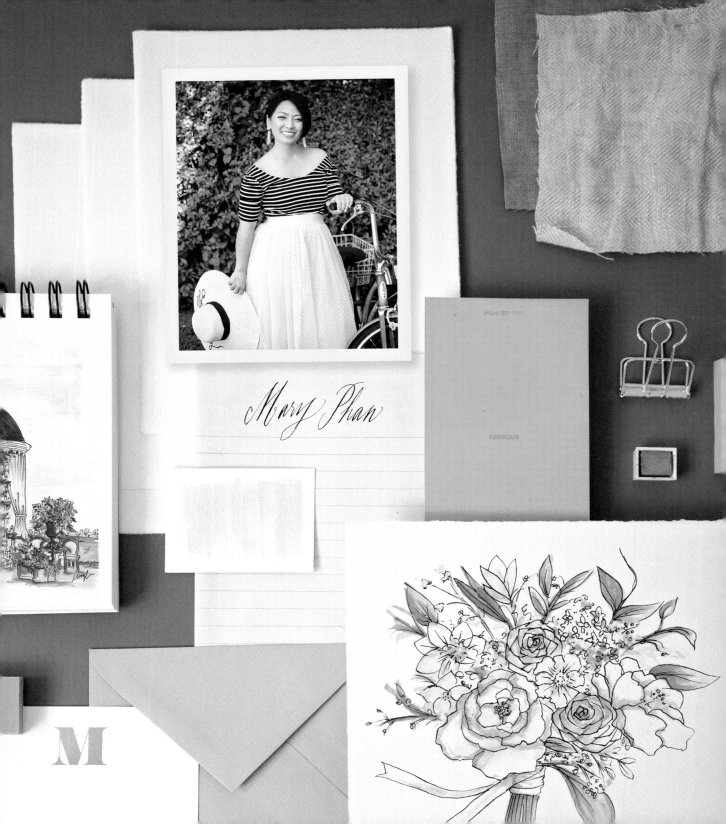

Mary Phan

FERROUS

M

INTRODUCTION

I'm so excited for you to go through the lessons in this book. I've created it especially for you so you can appreciate sketching in a whole new way. I want to help you learn new techniques, get inspired, and produce professional results that will wow your friends and family. My ultimate goal is to have you fall in love with sketching and enjoy it as much as I do. Even though I took many art and design classes in college, I was never taught to draw. Instead, through trial and error, I developed a style of my own.

Having taught many creative professionals through my workshops and e-course called "The Sketchbook Series," I know you'll find the following lessons useful in your every-day life. I love how my art has become a way to work with and support other artists and creative people. I love using it to empower and encourage people to pursue their creative passions. I want my art to inspire others to keep working toward their dreams. I want the lessons to inspire you to create beautiful pieces of artwork that you will be proud of.

This book presents tips and tricks that anyone can use, making the lessons easy to follow. I will take you step by step with exact details on how I produce each illustration. Don't be afraid to explore, make mistakes, and try again. I hope you find the lessons inspiring, and in time, develop your style so that you can share your newfound love with others. Let's start sketching!

GETTING STARTED

The Creative Environment

It is important to have an inspiring space to sketch in! It should feel open; not stuffy, cluttered, or messy. When I sketch, I look for areas that have nice natural lighting. At home, my desk sits near a window. If I'm out and about, I might find a table in a bright café or set up outside. All of these spaces help my creative workflow and put me in a clear state of mind.

Take the time to create a workstation or creative space just for yourself. It should be a quiet place in which you can take refuge after a long day—a sacred place for you to create. Make it your own; be as creative, playful, or colorful as you wish. This space should reflect your taste and style. Have fun with it since this will be a place in which you can expect to escape.

CREATIVE INSPIRATION

I have an "inspiration wall" next to my work area at home, and I encourage you to make one as well. I change up my inspirational wall seasonally or depending on the project that I'm currently working on. Start by coming up with a theme and choosing a color palette. Next, tear out inspirational images from magazines (*i.e.*, fashion, interiors, art, food magazines) or printing images from online to hang on the wall. For example, when I was thinking about this book, I envisioned Palm Springs meets Paris. I wanted fun, fresh, and bright colors, but also the sophistication of Parisian culture. Pull images of travel, art, places, locations, landmarks, fashion, florals, layouts, and scenes that center you back to your big vision or cohesive story. I also chose a color palette that felt summery and fresh, and with that, imagery that reflects those colors. Choosing a theme can help gather inspiration and help you stay inspired and focused when your ideas run out. I also like to hang artwork, fabric, color swatches, and things that I pick up on my walks, such as leaves or even dried flowers. The inspiration wall reminds me to be creative and often helps to jumpstart my next piece. Remember, there's no right or wrong here—just have fun! If you don't have a specific project you are working on, pull images that inspire you at the moment. If there's a reason why an image or object inspires you, then post it to your wall, too.

STORAGE AND DISPLAYING YOUR ART SUPPLIES

Spend a bit of time to organize your space and desktop. Consider your art supplies the foundation of how to produce great art. Find fun containers, cups, or jars to store your supplies. The key is to be able to find what you are looking for and maintain the tools you'll be investing in. Take care of your art supplies, and you'll see they will last longer. Learn how to properly store your brushes, pens, pencils, and erasers. For my markers, I like to have them displayed so I can see the cap colors. Make sure to store them away from direct sunlight so they don't dry out.

TOOLS AND MATERIALS

With your space all set, it's time to grab the proper tools and materials. For practicing the lessons, I suggest using an 8½-inch-wide by 11-inch-tall (21.6 x 28-cm) sketchbook or sketchpad. I've listed other types of paper on the following page that you can use once you are ready to apply the sketches on something to gift or even to celebrate your artwork.

Each artist uses different tools. For this book, I focus on using specific art markers, but feel free to use other types of mediums and brands to your liking. If you'd like to invest in the exact brand and colors I use to produce the results in the book, then you'll find them referenced at the beginning of each lesson.

Below is a list of supplies with my favorite brands:

PENCILS

- #2 pencil (Palomino Blackwing)
- 0.5mm Pentel mechanical graphite pencil
- Clear 12-inch (30.5-cm) ruler

DETAIL PENS

- 01/02/005/008 Micron waterproof black pens
- Le Pen (gray)

ART MARKERS

- Copic® markers

HIGHLIGHTING PENS

- Gold & white gel pens
- White color pencil

ERASERS

- Clicky eraser
- Kneaded eraser
- White plastic/vinyl eraser
- Gum paste eraser
- Pencil sharpener

SUGGESTED TYPES OF PAPER

There are several types of paper to choose from. I suggest going to a local art or craft store and looking for a smooth paper to start with. You'll find paper made just for sketching or mixed media in various paper thickness and paper weights.

- Travel sketchbook, any size
- Notecards
- Blank postcards
- Loose sketching paper
- Journals, notebooks, calendar books

FINDING PURPOSE

Subject and purpose go hand in hand, so it's important to determine why you are sketching. Are you creating an invitation to a birthday party? Are you documenting your travels? Are you guiding a design? Are you creating a gift for someone special? Once you settle for the reason you're sketching, you'll find inspiration can come from all sorts of places.

MY TOP 10 TIPS FOR SKETCHING

1/ Find natural light whenever possible.

2/ Wear comfortable clothing; avoid chunky or dangling wrist jewelry.

3/ Hold your pencil in a natural position.

4/ Draw the base items first, and start with simple shapes—squares, circles, rectangles.

5/ Details should come last.

6/ Sketch lightly.

7/ Don't be afraid to use your eraser to get rid of those mistakes; the beauty is that you can always start over.

8/ Adjust your grip; sometimes you'll need to hold your pencil firmly and other times you'll need to loosen up.

9/ Apply color in one direction.

10/ Apply different pressures to your pen to achieve different line weights, and to finish off your drawing.

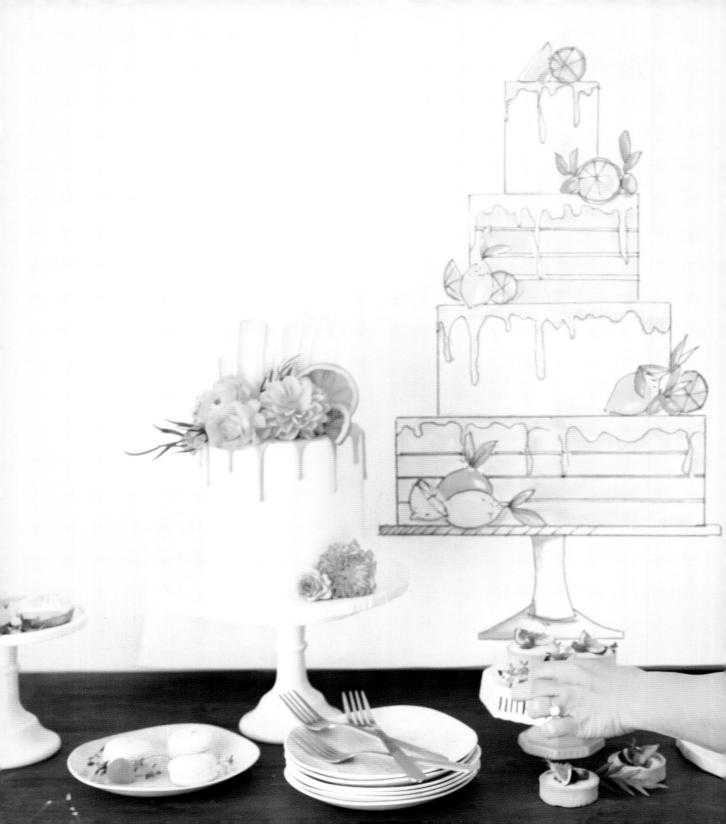

II.
CAKES AND DESSERTS

Learn Basic Structures with Guidelines

Have you ever walked into a stationery store, picked up a birthday card and thought how great it would be if you could sketch this for your mom, dad, brother, sister, or friend? I love personalized cards and have a feeling you do, too! This first chapter shows you how to sketch a cake and a fancy dessert station. I have a feeling you'll be creating lots of greeting cards after you walk through my lessons! I can't wait for you to dive in!

CREATIVE CAKE

Some of my favorite things to sketch are cakes and desserts! I once thought I'd be a cake baker, but soon realized I would rather sketch cakes than bake them. I'm inspired by all the amazing bakers who are artists in their own right, putting so much detail and texture into their creations. I hope you'll enjoy this citrus cake sketch. Once you go through my cake lesson, try incorporating your creativity to create different cake designs. Take some of the techniques and create your own versions. You might find that some ideas will come easy and others require research for a visual reference to add to your cake sketch.

MATERIALS

- 8½ x 11-inch (21.6 x 28-cm) paper/sketchbook or 5 x 7-inch (12.5 x 18-cm) notecard
- Mechanical or #2 pencil
- Kneaded eraser, erasers
- 12-inch (30.5-cm) clear ruler
- Black detail pen 01/005
- Gray detail pen

SUGGESTED COPIC MARKERS

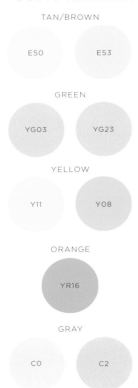

TAN/BROWN

E50 E53

GREEN

YG03 YG23

YELLOW

Y11 Y08

ORANGE

YR16

GRAY

C0 C2

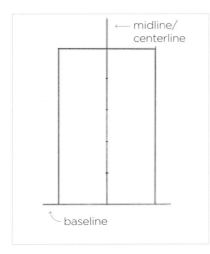

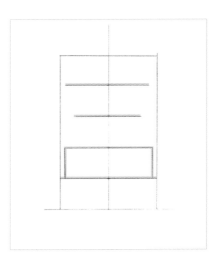

1/ Start by drawing a baseline about 4 inches (10 cm) in length. Then draw a vertical line 6 inches (15 cm) at the center point. This is our midline, or centerline.

Next, draw a box that is 3 inches wide by 5 inches tall (7.6 x 12.5 cm) centered on the previous baseline; this is going to be our "bounding box." A bounding box defines the width and top of the cake. This creates a box that frames the cake. The scale is important to make a note of so that the cake is not too wide or too skinny.

2/ Make a mark every inch (2.5 cm). Then draw horizontal lines across those marks. Draw a box to represent the bottom layer cake. Leave the base section empty, as that will be left to draw in the cake stand. The cake layer box should come in about ⅛ inch (0.3 cm) from each side of the bounding box. Drawing the bottom tier first allows you to build layers on top of your base layer.

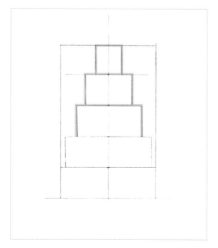 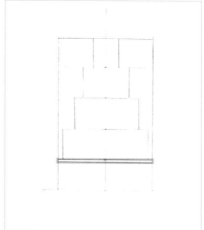 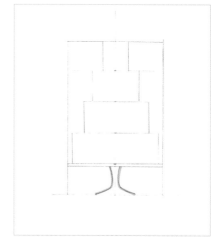

3 / To create the next layer, draw a box on top of the first cake tier. The box should come in about ¼ inch (0.6 cm) from the previous layer. Draw another box on top of the previous box. This box is ¼ inch (0.6 cm) narrower than the previous box.

Your top tier cake will be the narrowest layer of all, measuring ½ inch wide by 1 inch tall (1.2 cm x 2.5 cm). When you're done, you will have a four-tier cake. Make sure that the space on the left and right sides are equal distance. This spacing will ensure that the cake is in proportion.

4 / Now, to create the base of the cake stand, draw a thin line underneath and parallel to the first line. These two lines should be the same length and extend across the edge of the bounding box.

5 / To create the cake stand, draw a convex curve. Using the centerline as your reference point, start the convex curve about ¼ inch (0.6 cm) on the left side of the centerline. As the curve comes down toward the centerline, come in about ⅛ inch (0.13 cm), and finish the bottom of the curve back at ¼ inch (0.6 cm) from the centerline. Mirror the convex curve on the right side of the centerline. Extend the base of the cake stand on both sides about ½ inch (1.2 cm). Notice the subtle incline of both lines. Add a tiny vertical line on both sides to complete the edge or foot of the cake stand.

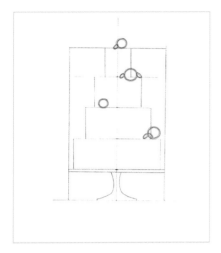
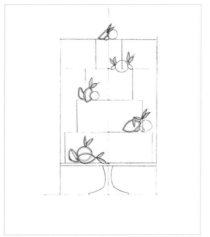
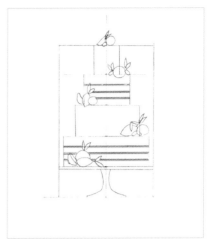

6 / The next step is to draw circles as placement guidelines for the fruit. Draw circles at the corners and places where you want to place your groupings. This fruitcake is made up of kumquat oranges, lemons, limes, and oranges. Think about their sizes in relation to each other. Oranges are the largest, indicated by the largest circle on the cake; kumquat oranges are about the size of your thumb and have an oval shape. Placement of the fruit groupings occurs in the middle of a layer or at the corners. Alternate and stagger the placement of each layer to show variety. This creates interest in your sketch.

7 / Next, draw the side of a lemon. The side of a lemon looks like a large leaf or football. Now add leaves and stems to your lemons. To create a cut lemon, draw half of a circle to represent the side wedges.

8 / Two of the cake layers will be unfrosted, exposing the layers within each layer. This is called a "naked" cake, which is a preferred style of cake among those who do not like frosting.

To draw the thin layers in between each cake tier, use a ruler to draw evenly-spaced double horizontal lines across the cake layer. In between each of these layers is frosting to hold the layers of cake together, but the outside will lack frosting. We will alternate the layers between "naked" and traditional "frosted" cake.

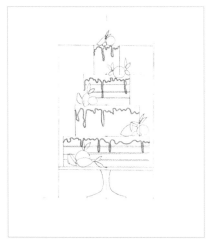
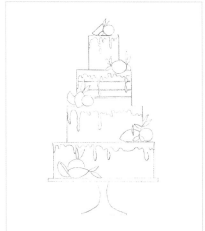
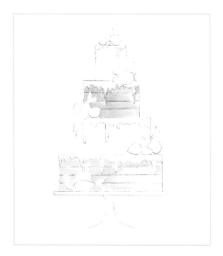

9/ On top of each layer is a caramel sauce that drips down the sides of the cake. With your pencil make sure to draw in squiggly lines, varying from long to short, to create a natural drip/drizzle.

10/ Now take your kneaded eraser and pull off the heavy dark lines. You can also use your kneaded eraser to erase the centerlines and bounding box. Make sure to leave behind only the things you want to color. Don't forget about all the corners where your fruits are sitting in front of. You want to make sure to erase those lines since the fruits sit in front of the cake. Now you have a clean cake ready for coloring.

11/ The following are colors that I used for my sketch. You can use whatever color combo in which you feel comfortable. Throughout the book, you'll see me reference Copic markers, my medium of choice. You will want to start with the lightest shade first, and then apply the next shade of color. I started with E50, which you can see on the base cake layer. Using the brush tip, color in one direction, and move from left to right. Make sure not to let the marker sit on your page, as it will bleed through the paper.

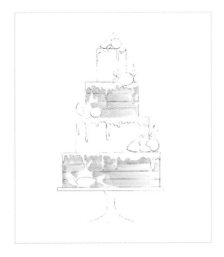 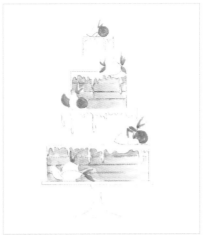 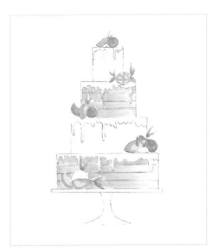

12/ Add a slightly darker shade (E53) by coloring over the first layer. However, let the first color layer show through. Decide which direction the light is coming from. For this sketch, the sun is coming from the top right side of the cake. You should leave a little bit of white on the right side as this shows a bit of highlight. Make sure to color in one direction, from left to right.

13/ To color in our limes and leaves, use a light shade of green (YG03). Use a sweeping motion when coloring the leaves.

Next, use a slightly darker shade of green (YG23). This is to show the second tone of the limes. When coloring the limes and leaves, just color enough to show a middle shadow.

14/ Color in the lemon with a light yellow (Y11). Just like the limes, to show a midtone, choose a slightly darker shade of yellow (Y08). Since the light is coming from the right side of the cake, the shadow will be on the left side of the lemons. Make sure to color in the midtone on the left side of the lemons.

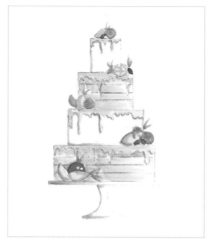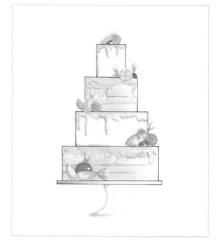

15/ Now color the kumquat oranges and oranges with the light shade of orange (YR16), leaving a highlight or white space on the right side of the fruit(s). If you wait for the marker on the page to dry, you can create a darker tone by going over it again with the same color.

Color the caramel dripping using the lightest tan tone (E50). Use a darker color (E53) to shade it in.

16/ For any part of the cake that is white, I recommend using a light shade of gray (C0). Since there isn't a white marker, you'll want to choose a light gray to show the shadow. Use gray (C0) to shade the left side of the cake stand and any white parts of the cake, since the light is coming from the right side. Also, color in areas that may cast a shadow such as underneath the caramel drips. Then choose a slightly darker shade of gray (C2) to show two tones in the shadows. Color over the initial gray tone. Apply light pressure using the brush end of the marker. Allow some of the first gray (C0) to be exposed.

17/ The final step is to ink our colored sketch. This step is important to make sure it pops off the page! Using the 01 black detail pen and a clear 12-inch (30.5-cm) ruler, outline the cake and cake stand. Take your time through this finishing step. Apply medium pressure, as you will notice that the heavier the pressure, the thicker your line becomes. The less pressure you apply, the thinner the line becomes.

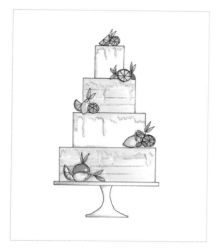

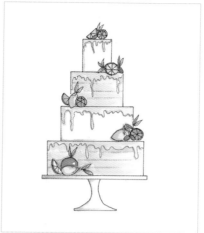

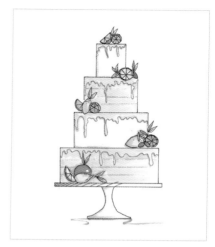

18/ For more delicate and finer details, use a thinner point black detail pen (005) and outline all of the fruits, leaves, caramel drizzle, and cake stand. Apply light to medium pressure and keep a steady hand. For added texture, draw in stipples onto the whole lemons and draw a thin inner circle to show the lemon/lime rinds. To draw a cut lemon/lime, imagine slicing the wedges like a pie or pizza. Don't forget to draw in the centerlines on the leaves to show the veins.

19/ For a less dramatic finish, use a gray detail pen (such as Le Pen) to outline the caramel drizzle. By using a gray detail pen for the finish in this sketch, it allows for the dripping to be more of a background detail instead of the main detail. Think of the black detail as the main character and the gray detail as a supporting character in the overall sketch.

20/ To avoid the cake falling flat, add textures to the final sketch. Use one of your black detail pens to draw diagonal lines on your cake stand edge. This technique is called crosshatch. Add stippling to your lemons for more detail (see Resources, page 149). Using your darker shade of gray (C2), draw "S" shapes on each side of the cake stand to show stylized shadows.

DESSERT STATION

Have you ever wondered how event professionals create masterful dessert stations? These dreamy displays are so awe-inspiring. I love a great production, especially when it comes to dessert displays! Perhaps you're thinking of throwing a social event, party, birthday soirée, baby shower, graduation party, special anniversary, or a low-key celebration. This is a great lesson for you to start getting your creative juices flowing! It's also a great way to get your ideas on to paper and wow your friends with your newfound creativity.

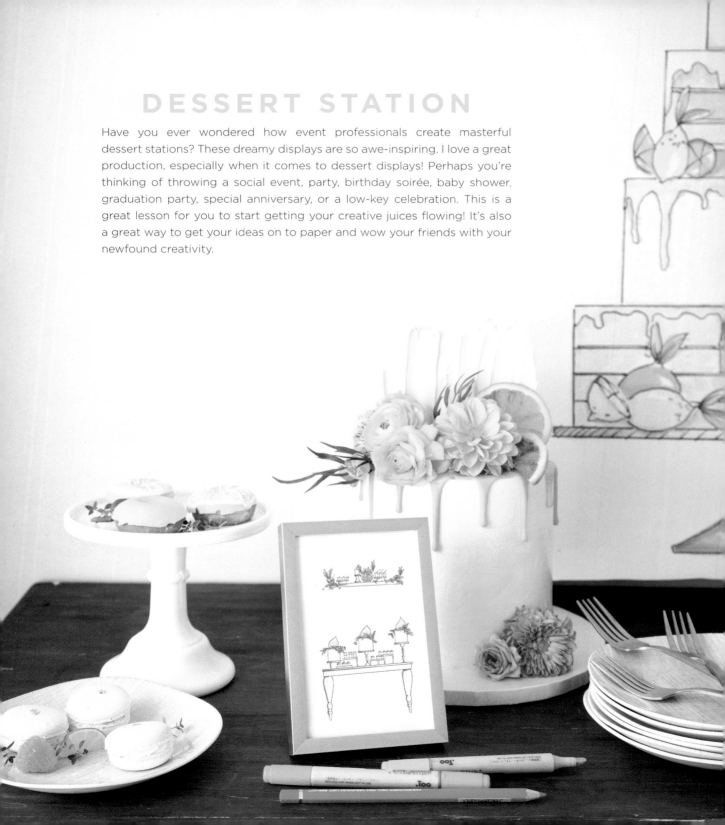

MATERIALS

- 8½ x 11-inch (21.6 x 28-cm) sketchbook or 5 x 7-inch (12.5 x 18-cm) notecard
- Mechanical or #2 pencil
- Kneaded eraser
- Clear ruler
- Black detail pen 01/005

SUGGESTED COPIC MARKERS

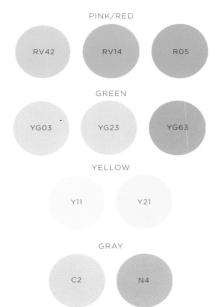

PINK/RED

RV42 RV14 R05

GREEN

YG03 YG23 YG63

YELLOW

Y11 Y21

GRAY

C2 N4

1/ Begin with your sketch paper or sketchpad in portrait view. Using your ruler, draw a 7-inch (17.8-cm) horizontal line 1 inch (2.5 cm) above the bottom of the page; consider this to be the baseline. Next, find the mid-point of the line at 3½ inches (9 cm) and draw a vertical line 8 inches (20.3 cm) for the centerline.

2/ First, we will draw the table. Start with a table frame that is 5 inches wide by 2½ inches tall (12.7 x 6.4 cm) and center it using the baseline. Next, divide the box in half and draw a centerline. Draw a line underneath the top of the box and then draw a horizontal line about ¼ inch (0.6 cm) below the previous line.

Next, we will frame the legs of our table. Measure out ½-inch (1.3-cm) thick legs on the left and right side of the table frame. Draw a horizontal line on each side of the legs to show breaks in the legs at ¾ inch (1.9 cm), measuring up from the base of the table frame.

3/ To create the turned style legs, start by dividing each leg frame in half by drawing a vertical line, with each side measuring ¼ inch (0.6 cm). Next, on the left leg start drawing a wide convex curve at the top, similar to a bowling pin shape. Finally, draw a roughly ³⁄₁₆-inch (0.5-cm) circle and add two ovals below it. Create the pegs by drawing two lines that angle in toward the centerline. Repeat these steps in the right leg frame, creating a mirror image of the left leg. Erase the bounding box and centerlines. Leave behind only the legs and tabletop.

4/ Next, draw three boxes in varying heights for the cakes, starting with the center box. Find the center of the table and draw a box that is 1 inch wide by 1½ inches tall (2.5 x 3.8 cm) right on top of the table. From the top of the cake frame, measure ⅝ inch (1.6 cm) and draw a horizontal line. Add another horizontal line below the first, spacing the lines ¹⁄₁₆ inch (0.2 cm) apart. This represents the cake stand plate thickness.

Now draw the right cake frame, measuring 1 inch wide by 1¾ inches tall (2.5 x 4.4 cm). Draw a vertical line down the center of the box. From the top of the cake frame, measure ⅝ inch (1.6 cm) and draw a horizontal line. Add another horizontal line below the first. To draw the left cake box frame, measure a ¾-inch-wide by 1-inch-tall (1.9 x 2.5-cm) box. From the top of the cake frame, again measure ⅝ inch (1.6 cm) and draw a horizontal line. Add another thin horizontal line below the first.

5/ The beauty of styled tables is layering in other types of desserts with the cakes. To do this, add a box that is ½ inch wide by ¾ inch tall (1.3 x 1.9 cm) in between each cake frame. You should end up with two identical boxes in between the left cake frame and middle and another box between the middle and the right cake frame. To draw a plate, draw a rectangle box that is ¹⁵⁄₁₆ inch wide by ¹⁄₁₆ inch tall (2.4 x 0.2 cm). Lastly, draw another box measuring ¹⁵⁄₁₆ inch wide by ¼ inch tall (2.4 x 0.6 cm). Make sure this box overlaps the middle cake frame and the fourth box.

TIP: When thinking about elaborate dessert stations, know that the tallest object sits in the back, middle-sized objects sit in front of the tall objects, and low items are in front. In sketching, it's important to note the stacking order, as well.

6/ Next, add in desserts and draw the cake layers. Start by freehand sketching the cupcakes. To do this, draw trapezoid shapes for the cupcake base and half circles for the tops. To make the glasses, draw three individual ¼-inch (0.6-cm) high trapezoid shapes. Next, draw a horizontal line in all the glasses to show the height of the milk. Finally, using your ruler draw vertical lines ⅛ inch (0.3 cm) from the cake frame to show the sides of the cakes.

To draw the stems of the cake stands, start on the far left by drawing an enlarged half-curve, resembling a parenthesis. Next, work on the middle cake stand which has a more ornate stem. Begin by alternating small curves, inverted curves and round shapes down the stem of the cake stand. Feel free to get creative here! Then finish out the last cake stand in the same pattern as the middle stem.

7/ To add detail, use your mechanical pencil to sketch in squiggly lines on each of the cakes. This represents the flowers that are sitting on top of each cake. Make them loose and whimsical!

Next, add in leaves to each of the cakes. Each cake has a teardrop-shaped chocolate structure, starting at the top point and widen out as you get toward the base. The teardrop shape should be about ⅜ inch (1 cm).

8/ Now we will draw the overhead hanging desert station. Find the centerline and measure 6½ inches (16.5 cm) up from the baseline. Then draw a 4-inch-wide by ¼-inch-tall (10.2 cm x 0.6-cm) rectangle. Make sure to center it on the midline.

Find the center of the rectangle (at 2 inches [5 cm]) and draw a box that is ⁵⁄₁₆ inch wide x ¾ inch tall (0.8 x 1.3 cm). Next draw a horizontal line halfway through the box. This box will be the floral arrangement and the start of the vase. Then on the left of the floral arrangement, draw a box that is ³⁄₁₆ inch wide by 1 inch tall (0.5 x 2.5-cm) for our candle. Next, add a rectangle measuring ⅜ inch wide by ¼ inch tall (1 x 0.6 cm); this will hold the dessert cups with spoons. Lastly, on the left side about ¼ inch (0.6 cm) from the edge of the hanging piece, draw a box measuring ¾ inch wide by ⅛ inch tall (1.3 x 0.3 cm).

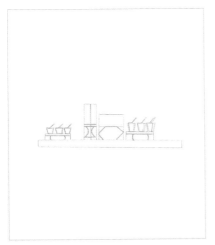 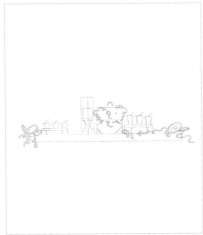 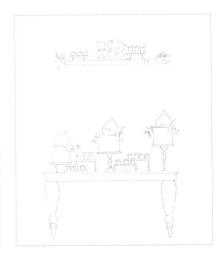

9/ Next, divide the boxes in half. Take your ruler and draw horizontal lines for the tops of the cake stands. Add a half round on one side of the cake stand and mirror it on the opposite side to complete the cake stand. Draw in three trapezoid shapes for the dessert cups and add a diagonal line to represent a dessert spoon on top of each cake stand. To draw the candlestick, add in a horizontal line about ¾ inch (1.3 cm) down from the top of the box. Add another about ⅛ inch (0.3 cm) below that first line. Then add a convex curve and mirror it on the right side. The last step to complete the candlestick is to draw a horizontal line about ⅛ inch (0.3 cm) from the base of the box. For the centerpiece, use your ruler and draw a geometric shape. You'll notice that I cut the candle in half; this is to help guide me to creating mirrored images. When you're working with smaller elements, center-lines are not always necessary.

10/ Draw in squiggly lines and rosettes for flowers, starting with the florals that sit inside of the vase. Draw in fluffy clouds and random squiggly lines. Next, draw in rosettes on the right and left corners. It's okay to let loose and be a bit free-form here. Add more squiggly lines around the rosettes along with leaves. Keep scale in mind here, as the size of the rosettes should be the same size as the desserts.

11/ Now take your kneaded eraser and pull off the heavy graphite lines. Erase all the lines that you do not want in your final sketch.

TIP: It's good to have odd numbers such as 1, 3, and 5. In this case, we ended up with 5 leafy branches, which balances out the entire space.

12/ Now we are ready for color, starting with the lightest color first (RV42). With the brush end, use the stipple technique to color in your flowers. Similarly, add color to the tops of your cupcakes. Try holding the markers like a paintbrush and imagine you are painting in the colors.

13/ Using your second tone of pink (RV14), continue to add the stippling technique. Stipple in more color to the flowers and on top of your cupcake. You should be able to see both colors.

Now add the darkest tone to show shadow (R05). A little goes a long way here.

14/ Starting with the lightest shade first, color in your flowers (RV42). Color in the rosettes in a spiral pattern. Do not let the marker sit on the paper, as it will bleed through.

Use your second tone or midtone (RV14) to layer the top of the rosettes.

15/ To color in the leaves, use the lightest shade of green (YG03). Using a feathering stroke/technique, flick your wrist up and away from the stems.

Next use a midtone green (YG23) to color over the leaves. Start at the base of the leaf and lightly feather the stroke toward the outer leaf. Finish off the leaves by adding one more layer with a dark shade of green (YG63) to show shadow.

16/ Using a bright yellow (Y11) color in the tops of the cakes and a few of the desserts on the shelf.

Use a slightly darker tone of yellow (Y21) to color in the base of the teardrop shape for a shadow. Start drawing from the base and move up in a feathered motion.

17/ Next, we want to show a shadow on our table and white cake stands. Use the lightest shade of gray (C2) and color everything on the left side, including the legs and the cake stand. Leave the right side white to show highlights and light coming from the right side. Then add your darker shade of gray (N4) using the tip of your brush end to outline the far-left edges.

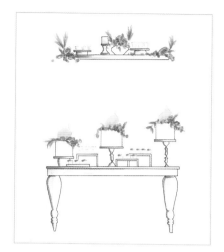 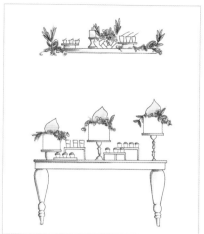 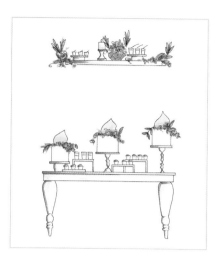

18/ Now you're ready to add the final detail to your cake station. Using a 01 black detail pen, take the ruler and with light pressure, outline the tabletop, legs, and hanging piece. Continue to outline the rest of the drawing, using the ruler to outline the cake stands, cake, dessert displays, centerpiece, and candlestick.

19/ For the delicate details, use the thinner black detail pen (005). With light pressure and in a quick motion, add squiggly lines for the fillers, and outline the rosettes for flowers, the leaves, all of the desserts, and the geometric shape on the centerpiece.

20/ For the finishing touch, use the gold metallic pen to add a little shimmer to the vases and flowers. This is one of my favorite details to add, as it is a bit unexpected.

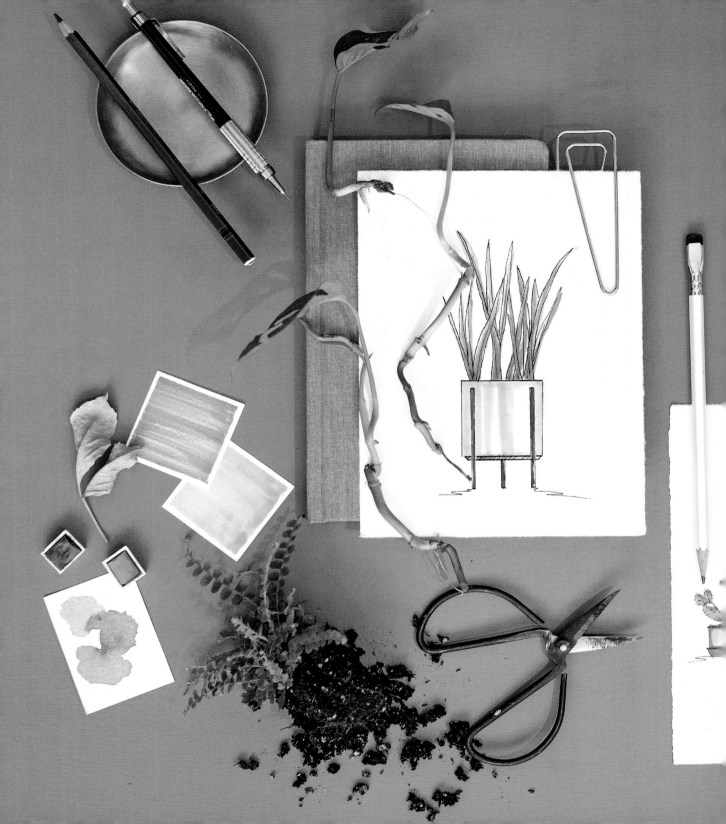

III.
LET YOUR
IDEAS
BLOSSOM

Go with the Flow

When I was a little girl, I loved spending time in my parents' backyard. It had lots of fruit trees, herbs, and even a chicken coop. It was always fun to imagine what my backyard would be filled with one day. As I got older, I really began to appreciate design and how it played important roles in my everyday life. In this chapter, I've included a floral arrangement lesson so that you can begin to think of form and function. Then, we discuss gardening, leading to a more structured lesson. It's a bit of a juxtaposition, but I think it gives a good balance between when to be structured and when to let loose— an important fundamental lesson in sketching.

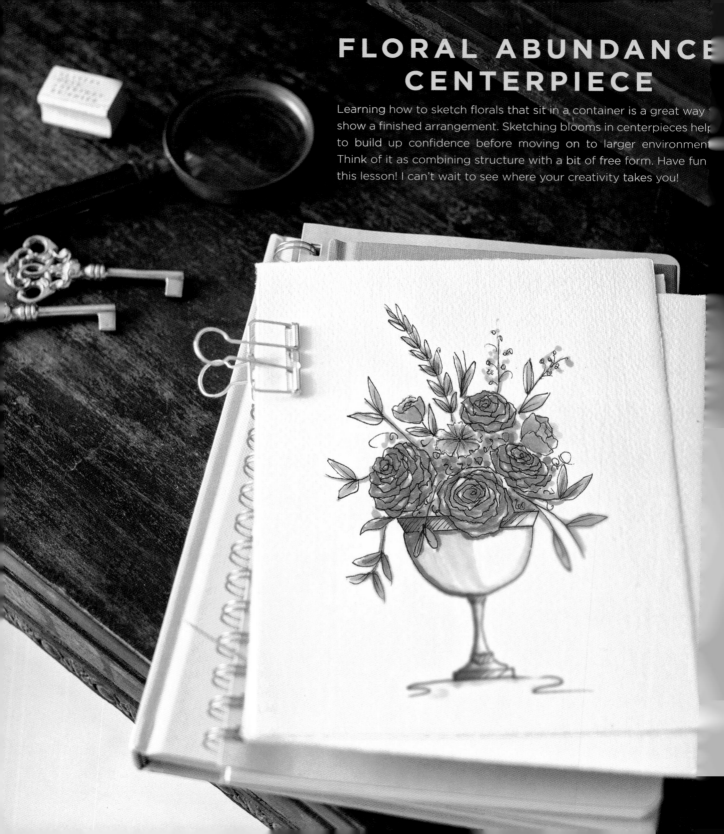

FLORAL ABUNDANCE CENTERPIECE

Learning how to sketch florals that sit in a container is a great way to show a finished arrangement. Sketching blooms in centerpieces help to build up confidence before moving on to larger environment Think of it as combining structure with a bit of free form. Have fun this lesson! I can't wait to see where your creativity takes you!

MATERIALS

- 8½ x 11-inch (21.6 x 28-cm) sketchbook or 5 x 7-inch (12.5 x 18-cm) notecard
- Mechanical or #2 pencil
- Kneaded eraser
- Clear ruler
- Black detail pen 01/005

SUGGESTED COPIC MARKERS

PINK/RED

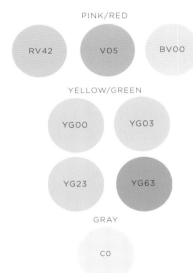

RV42 V05 BV00

YELLOW/GREEN

YG00 YG03

YG23 YG63

GRAY

C0

1/ Using your ruler, draw a floral box frame that is 1½ inches tall by 1¾ inches wide (3.8 x 4.5 cm). Divide your box in half by drawing a vertical line down the center. Remember to sketch lightly! The measurements are to give a general guideline to size and scale. When drawing your sketch, keep scale and proportion in mind. You don't want your vase too big for your florals or vice versa.

2/ Using your ruler, draw the lip of the vase at ⅛ inch (0.3 cm) below the top of the floral box frame. Add the bowl of the vase by drawing a curve on the left and right side of the centerline. Make sure that the curves mirror each other. The depth of the bowl should be roughly ¾ inch (1.9 cm) below the lip of the vase.

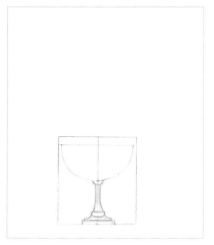 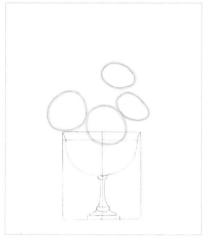 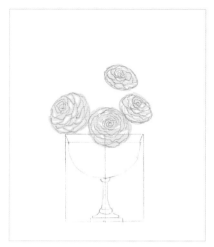

3/ Add in the top part of the center-piece stem by drawing a small oval shape. Next, add a curved line for the stem; make sure to keep the lines closer to the centerline. Slowly flair out your lines as it gets closer to the base of the vessel, which should be ½ inch (1.3 cm) in length.

Next, draw a small oval slightly larger than the first. Continue to angle out the left and right lines, roughly ¼ inch (0.6 cm) on each side.

To finish out the base, use a ruler to draw a box that is ⁵⁄₁₆ inch wide by ¹⁄₁₆ inch tall (0.8 x 0.2 cm). Make sure that you are using the midline to center the box.

4/ Next, we will be drawing circles as guides to place the main blooms. Draw two larger circles roughly ¾ inch (1.9 cm) in diameter. These larger circles will be the focal blooms and sit toward the front. Then draw two slightly smaller ovals at roughly ½ inch (1.3 cm) in diameter, one on the top right and one adjacent to the larger bloom. Generally, I like to start a focal right in the center and then place my other blooms around the main center bloom.

5/ Start by sketching a simple rose. Place your pencil tip in the center and spiral out to draw the beginning of a tight bud. As you move in a circular pattern, have some of the points touch the previous spiral. Form some lines that are close and some that show the petals opening a bit. As you continue to draw, start opening up space between the spiral courses so the petals start to expand as you get toward the outside edge of the circle (see page 152). Finish all of the circles with simple roses.

TIP: Alternating the view from centers to angled roses gives the centerpiece a more realistic and natural look.

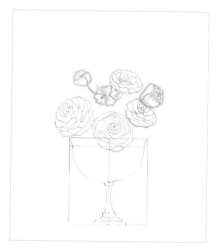
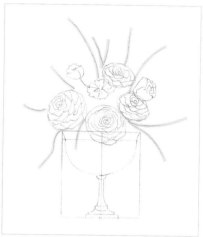
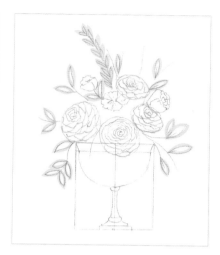

6/ To add in filler flowers, start by drawing a pizza slice shape with jagged edges. Continue drawing slices until you complete the whole pie. Next fill in the smaller flowers in between the white spaces, adding some smaller florals with a stem. To do this, draw a "U" shape and finish off the tops with jagged edges. Draw the next petal with a half "U" behind the first petal. Create a jagged edge in a half-circle pattern over the top of both petals. Add a stem that connects it to the closest flower.

For the flower that's off to the side in between the roses, angle the "U" shape about 45 degrees and finish off the top with a jagged edge. Add a petal on the left side of the "U" shape, finishing the top with a jagged edge. Add in smaller petals, building layer by layer toward the top part of the flower (see Simple Anemone in Resources if needed on page 152).

7/ Add curved lines to show where you want your leaf branches. Keep the tallest branch at the maximum of 1 inch (2.5 cm) and smallest about ½ inch (1.3 cm). There is no specific way of drawing stems; make sure to add more curves as they come out of the floral arrangement. Also, make sure that some stems are longer than others. Try to let loose here.

8/ Add different leaves to each branch (see Leaves section in Resources on page 153). Start anywhere on the stem and create your first half curve. Complete the curve by coming to a point. Next, start inside of each leaf and using a feather motion, add a center vein for some of the larger leaves. Notice that the leaves here are thin and narrow. Start at the top of the branch and continue adding leaves down to the curve of the stem.

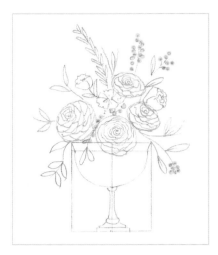 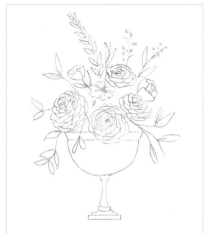 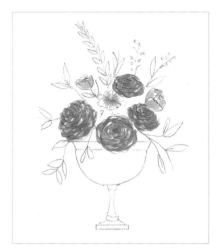

9/ Add in berries by starting with a thin stem. Apply light pressure to your pencil on delicate details. Add more small stems branching out from the center and draw small circles to the tops of some of the previously drawn stems. Continue to add small circles and more round-shaped leaves to fill in the white areas.

TIP: It's okay to leave a little bit of white space, as you don't want to fill every space up with berries or leaves.

10/ Once you are done adding in fillers, take your kneaded eraser and pull off the dark lines leaving behind a light sketch. Erase your guidelines and leave behind only what you want to color. This should be the container and the florals.

11/ Now it's time to color! Choosing color is sometimes the toughest part, but I like a light, middle, and dark tone (to show shadowing). Use the lightest shade first (RV42) to color the blooms. Using the brush side of your marker, color in the rose petals, leaving a little bit of white space for highlights. Use the stippling technique to dot in color (see page 149).

Next, use a midtone red (V05) to color in all the roses using the stippling technique (see page 149). Make sure that you are not filling in the rose completely with color, but adding color sparingly. This will allow you to see the first shade of color. The goal is to be able to see all of the tones.

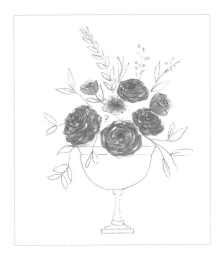 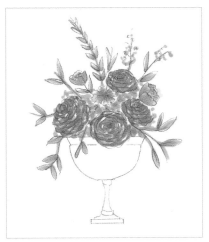 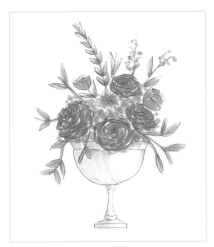

12/ Next I added BV00 to the smaller blooms. It's always nice to have at least two tones in your flowers.

For my centers, I added a little hint of yellow (YG00).

> **TIPS:** Choosing a light, middle, and dark tone gives dimension to your shapes.
>
> The darkest shade of color should be thought of as the shadow color of your bloom. Hence being the darkest shade of the three colors.

13/ Now we are ready to color in our green leaves. I started with the lightest shade of green (YG03). Use the brush end of the marker and move in quick sweeping motions. First, draw the stem of the leaves, and color them in. For areas that were left white, fill in by stippling the centers of the arrangement as well as the berries. The stippling gives the arrangement a bit of texture.

Next, add in the second tone of green (YG23) to fill in the centers of the leaves. Again using the brush end of the marker, lightly go over the stems and create a quick dot-and-pull motion on the leaves.

14/ Time to shade your floral container. To do this, choose the lightest shade of gray (C0) and decide on the direction of the light. I decided that the light is coming from the right side, so I kept the right side of the container white to show a highlight. Using the brush end of your marker, outline the entire vessel first and then begin to fill in one direction. If you are working on the round part of the bowl, start at the top and curve down to the bottom of the bowl base. Continue the next stroke, in the same manner, starting at the top and curving down to the bowl base. This allows the marker line to stay consistent all the way through. Notice that there is also a thin highlight on the stem of the vessel, as well.

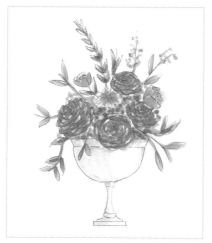 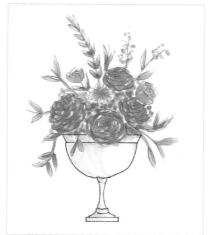 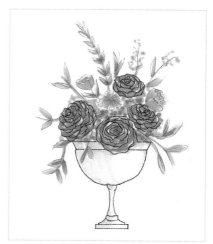

15/ You'll notice that my dark shade of green did not go in a logical order. The reason is that often I like to color other objects to see if the third color is necessary, or if I need to change up the tone I originally chose. Feel free to do the same.

With the darkest shade of green (YG63), continue stippling the centers of the arrangement and lightly lining the stems and centers of the leaves.

16/ The final segment is to add the black outline. This is my favorite part because you can start to see the image come alive! Using your black detail pen (01), outline the vase with light to medium pressure. Notice how you hold your pen. By loosening your grip, you'll end up with a thinner line. By having a tighter grip and pressing down on the paper, your line becomes thicker. Also, the looser you hold your pen, the more control you tend to have.

TIP: Try not to have sketchy lines but rather solid strokes or single line strokes. This tends to present a more confident and bold line.

17/ Next, choose a thinner black detail tip (005) to outline (with light pressure) all of the roses. Start at the center as you did when you initially began to sketch the rose. Remember to start with a tight spiral and continue to work your way around, weaving in and out from the previous petal. After five rotations, begin to open up and enlarge the petals slightly, gradually opening them toward the outside.

For the tilted roses, notice how the spiral center sits more toward the top of the flower and the petals circle more toward the front. The petals still gradually become larger as you come toward the outer edge. They just don't follow a spiral pattern as in the middle rose.

TIP: Different viewpoints will make the roses look different. Practice the different angles from which you can draw a rose.

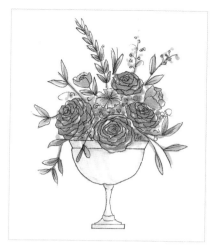 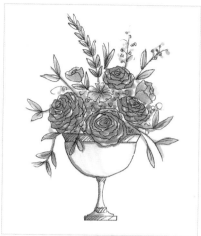 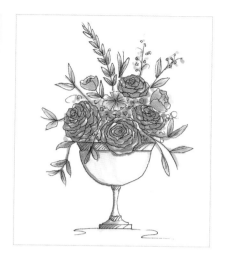

18/ Continue with the fine black tip (005) to outline in the filler flowers, berries, and details. Start with light pressure, drawing in the stems and adding in the leaves. Add in your center veins. Next, add circles to your berries. Notice mine are not perfectly round or exact. Don't forget to add curlycues and squiggly lines to the edges and center of the arrangement for a bit of whimsy!

19/ To add a bit more interest to the final piece, add short diagonal lines to your vase in areas that would have shadows, such as the container lip. Another area where I would add the diagonal lines would be underneath the bowl. Since the bowl protrudes, it would cast a shadow underneath the stem. Add the diagonal lines on the bubble and rectangle base. Coloring in the shadow adds dimension to the vase. I also chose a darker shade of gray (C5) to add depth to the left side of the vase.

20/ Finish off the sketch using your C0 gray marker. Add an "S" shape on each side of the vase for a little bit of character! Continue the last step by using your black detail pen (005) to outline the "S" shape on each side of the vase.

As much as I love plants, I don't have much of a green thumb. I love plants that are low maintenance. When I was thinking about this lesson, I included a cactus, succulent, and spider plant because they all have a unique shape to them. This will give you a basic understanding of how to draw different shapes so you can start looking at other plants and the shapes they produce. I can't wait to see how this lesson will inspire you to sketch other plants for your garden scene.

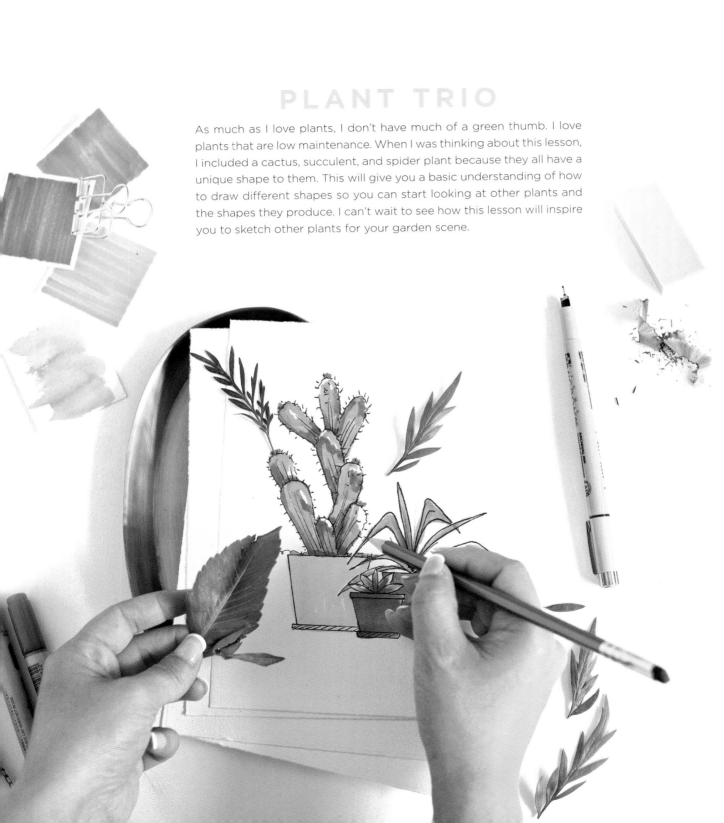

MATERIALS

- 8½ x 11-inch (21.6 x 28-cm) paper/sketch-book or 5 x 7-inch (12.5 x 18-cm) notecard
- Mechanical pencil or #2 pencil
- Kneaded eraser
- Clear ruler
- Black detail pen 01/005

SUGGESTED COPIC MARKERS

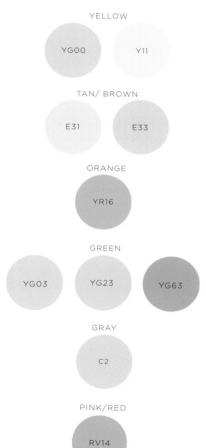

YELLOW

YG00 Y11

TAN/ BROWN

E31 E33

ORANGE

YR16

GREEN

YG03 YG23 YG63

GRAY

C2

PINK/RED

RV14

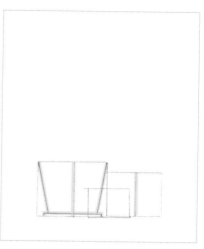

1/ Using your ruler, find the center of your page and draw a baseline at the bottom of your paper, roughly 3 inches (7.6 cm) wide. Along the baseline, draw three boxes with one box overlapping the two boxes. First, draw the largest box to be 1¼ inches wide by 1 inch tall (3.0 x 2.5 cm). To the right of this, draw another box 1 inch wide by ¾ inch tall (3.0 x 1.9 cm). Lastly, in front of and in between the two boxes, draw a smaller box ¾ inch wide by ½ inch tall (1.9 x 1.3 cm), slightly below the baseline. These box frames will be the guidelines for the planters.

2/ Next, draw in the centerline on each of the boxes. Use the ruler to measure the middle of each box and draw a vertical line. Beginning with the largest planter box, take your ruler and draw an angled line, starting at the top left corner of the box and coming in ¼ inch (0.6 cm) from the bottom. Make sure to leave space at the bottom of the planter for a rectangle box. Next, mirroring the left side, place your ruler on the right side of the large box, ¼ inch (0.6 cm) from the bottom right, and draw an angled line. Lastly, draw a 1-inch-wide by ¹⁄₁₆-inch-tall (2.5 x 0.2-cm) rectangular box for the planter base.

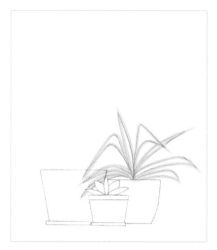

3/ Starting with the medium-sized box, draw a curved line starting at the top right corner, ¼ inch (0.6 cm) in from the bottom right of the box. Mirror the curve on the left side. Since the smaller planter box sits in front covering this planter, use dotted lines to complete the curve. You will eventually erase the dotted lines.

For the smallest planter box, measure ⅛ inch (0.3 cm) below the top of the line and draw a horizontal line for the lip of the planter. Then at the bottom of the box, measure ¹⁄₁₆ inch (0.2 cm) up from the bottom and draw a horizontal line. Next, start at the left corner below the lip and draw an angled line about ⅛ inch (0.3 cm) in from the bottom left base. Mark the right corner below the lip and draw an angled line ⅛ inch (0.3 cm) from the bottom right base.

4/ Erase your centerlines and boxes, leaving behind only the plants and planter boxes.

Begin drawing the succulent by starting with the middle leaf. From the base of the leaf and top of the smallest pot, draw a ¼ inch (0.6 cm) curved line. Finish the leaf by mirroring the curve. Continue to draw the other leaves, one at each side of the center leaf. You should have a total of three pointed leaves.

Add tips of pointed leaves in between each leaf previously drawn. Instead of drawing the whole leaf, you'll be drawing just the top as it peeks from behind the first three leaves. And there you have it: your 2D succulent plant. It is that easy!

5/ Next, we'll draw the leaves of the spider plant. The spider plant is known for its long and wispy leaves, sometimes drooping to the floor. Start at the top and center of the medium planter and draw a hook or boomerang shape about 1 inch (2.5 cm) in length. Add the remaining part of the hook, also 1 inch (2.5 cm) long. The irregular shaped leaves should vary in length and curvature. Continue to add more long and irregular hooks and shapes.

Then add more elongated curved leaves to fill in the planter with a few sticking straight up and some curving to the left. Stick to eight or so leaves so that the plant doesn't fill the entire space.

TIP: With practice, you'll learn how many leaves balance the sketch. It's a matter of pulling back from your drawing to see if it's too heavy on one side or not enough.

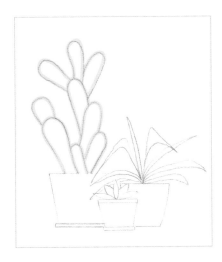

6 / Next, work on the tall cactus. Start by drawing a long loop and angle it toward the left, about ¾ inch (1.9 cm) long. Next, draw a slightly longer loop about 1 inch (2.5 cm) in length angled toward the right, slightly thicker than the first arm. Then continue drawing a longer loop behind the last arm. To draw the next set, angle the loop toward the left and draw these arms slightly wider than the previous three. Keep the width roughly ½ inch (1.3 cm). Draw another arm peeking out behind at the same angle.

For our last grouping of four arms, follow the angle of the original set and draw a long loop. Draw three continuous arms behind it, fanned out so they sit more naturally. Take your kneaded eraser and pull off dark pencil lines, leaving behind a light sketch.

7 / Now it's time to add color! I like to have a light and midtone chosen for each different planter. I used yellow (YG00, Y11), tan (E31, E33), and orange (YR16) for coloring the planters.

Use your lightest shade for each of the planters to color in each of the planter vases. Color from top to bottom using the brush end of your marker. Do not let the marker tip sit on the page, as you will want a continuous stroke, creating consistent color and markings. For rounded planters, color in horizontal curved strokes along the middle. For each of the shades, color in one layer and leave a little bit of white on the right side of the planters for highlight.

8 / Next, choose your second tone of color for each of the planters. Color the left most planter using the yellow shade (Y11). For the smaller planter, use orange (YR16) and color it from top to bottom. Then color the bottom of the base from left to right. Finally, color the rightmost planter and its base from left to right using a light brown (E33). For the rounded or curved areas, color in a curved pattern.

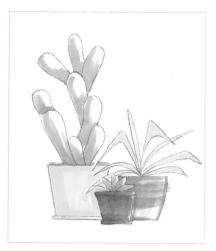 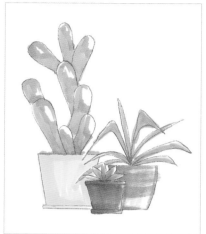 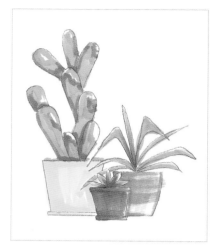

9/ Choose the lightest shade of green (YG03) for your cactus and succulents. Color in one direction. With the brush end of the marker, start coloring from the base and lightly brush up. Leave negative space for the next colors. Lightly add in the mossy greenery on top of the planter, alternating between light and thicker strokes to give a bumpy finish. Next, color in the succulents with the midtone green (YG23), starting at the center. Use medium pressure when you start and ease up as you get to the outer edge. Leave a bit of white space for highlights.

Take your second tone of green (YG23) and add the midtones to the cactus. Color from the base and in between the joints of the cactus arms and color on the left side of the cactus arms. Next, color in the spider plant by adding a light yellow (YG00) to all of the branches.

10/ Using the midtone tone green (YG23), color in the remaining part of the cactus, leaving a little bit of white space on the right side of each arm. The highlights are important so that it looks realistic. Stipple in color on the moss/greenery above the planter.

Next, start at the center of the succulent and use a small brush stroke; you'll want to make sure the first layers are seen. Then, color in the leaves of the spider plant, exposing the yellow layer.

> **TIP:** 3D objects should have at least two tones in them so they do not look flat.

11/ Add the darkest shade of green (YG63) where the cactus arms meet at the base of the cactus. You can add shading in other areas too, but do not overpower the cactus; use sparingly. Add some shade to the base of the planter.

Next, layer in the green (YG63), starting from the centers of the spider plant and lightly pulling out toward the edge of the leaves. Then, add color starting on the inside of the succulent and pulling the color toward the edge.

> **TIP:** When choosing colors, select shades that are not complete contrasts to each other—this will help the colors to blend better.

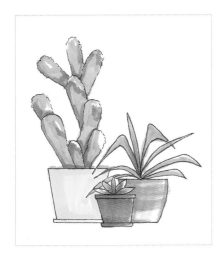
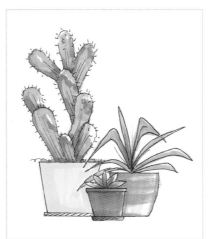
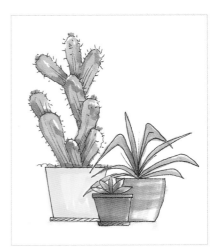

12/ Time to outline! Use your black detail pen (01) to outline the planter boxes and outer leaves. Starting with the cactus arms, use squiggly lines and some straight lines since the plant has a rough surface. It's good to add in textures here to indicate the uneven surface.

Next, outline the spider plant leaves. Keep a consistent stroke and do not lift off the paper until you finish one edge of the leaf. Try to start at the base and move the stroke up to the tip of the leaf and then complete the other side of the leaf.

For the succulent, lighten the grip since it is a smaller plant. You might be able to gain more control if you loosen your shoulders and hold the pen about 1 inch (2.5 cm) away from the tip. Start at the base of the plant and move toward the outer leaves.

13/ Using the black detail pen (005), draw thin lines on the cactus. Start at the base and draw up lightly toward the tip of the cactus. Next, add dash lines around the rounded portion of the cactus and stipple in a few on the arm of the cactus to show the cactus spikes. Add squiggly lines on the base to show a textural element. Add center veins on the larger spider plant leaf. Add lines outside of the plant for more texture.

Add diagonal lines on the base of the planter to show a shadow. Keep the diagonal lines going all in one direction for consistency

14/ Using a bright pink (RV14), add a couple dots for your cactus florets at the top of five cactus arms. Feel free to leave off some florets so they are not on every arm, which will give a more natural look. Use a gray marker (C0) to add a shadow to the base of your planters.

And there you have it, a complete plant combination, ready to gift to your friends!

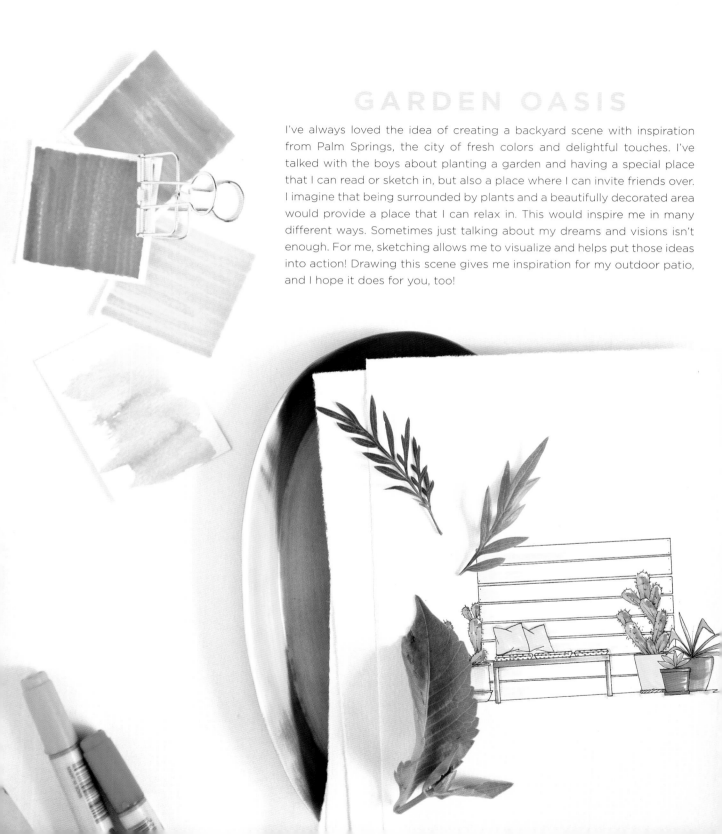

GARDEN OASIS

I've always loved the idea of creating a backyard scene with inspiration from Palm Springs, the city of fresh colors and delightful touches. I've talked with the boys about planting a garden and having a special place that I can read or sketch in, but also a place where I can invite friends over. I imagine that being surrounded by plants and a beautifully decorated area would provide a place that I can relax in. This would inspire me in many different ways. Sometimes just talking about my dreams and visions isn't enough. For me, sketching allows me to visualize and helps put those ideas into action! Drawing this scene gives me inspiration for my outdoor patio, and I hope it does for you, too!

MATERIALS

- 8½ x 11-inch (21.6 x 28-cm) sketchbook or 5 x 7 inch (12.5 x 18-cm) notecard
- Mechanical or #2 pencil
- Kneaded eraser
- Clear ruler
- Black detail pen 01/005

SUGGESTED COPIC MARKERS

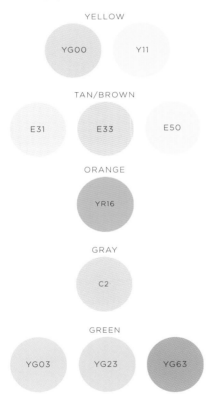

YELLOW

YG00 Y11

TAN/BROWN

E31 E33 E50

ORANGE

YR16

GRAY

C2

GREEN

YG03 YG23 YG63

1/ Start with your paper and a pencil. Turn your page to a landscape format. Using your ruler, draw a box 5 inches wide by 4 inches tall (12.7 x 10.2 cm), with a centerline to divide the box in half. Position your box at least 1½ inches (3.8 cm) above the bottom edge of your paper.

Using the centerline again, create a mark at every ½ inch (1.3 cm), 7 total. These will be the slats of our back wall.

2/ Use your ruler to draw horizontal lines all the way down the box. Hold the ruler steady and create straight, spaced lines.

Above every line, either measure ¹⁄₁₆ inch (0.2 cm) or smaller and draw horizontal lines all the way to the sides. Make sure the lines are parallel to each other.

TIP: Another way to create perfectly straight horizontal lines is by marking the left and right side of the box at every ½ inch (1.3 cm) and connecting the lines across the wall.

3/ Next, we'll draw the bench! Draw a rectangle 3 inches wide by 1⅛ inches tall (7.6 x 2.9 cm) positioned ⅝ inch (1.6 cm) to the right of the box and roughly ¹⁄₁₆ inch (0.2 cm) below the base of the back wall. Draw the centerline of the bench at 1½ inches (3.8 cm) inside the rectangle box. Use your eraser to pull off the back wall lines while you work on the bench.

Now to add the legs and the top of the bench. Starting on the left side of our box, draw two vertical lines ⅛ inch (0.3 cm) apart and repeat the same steps to complete the right leg.

Then draw the thickness of the bench by drawing a horizontal line ¼ inch (0.6 cm) below the top of the bench.

4/ To draw in the cushions, add "<"-shaped brackets at roughly every inch (2.5 cm) along the seat of the bench. To do this, start on the left side and add "<". Then space out an inch and draw the opposite bracket ">". Again start with another bracket "<", space out an inch and close the bracket ">". Finish with one more set so you have three sets total.

Next, take your ruler and create the tops and bottoms of the cushion. Draw the seams of the cushions by drawing a horizontal line through the middle of the cushion. It's okay not to finish the whole line all the way across.

5/ Now we'll begin to draw in the pillows. Starting with the far left corner, draw a cat ear shape roughly ½ inch (1.3 cm) at the farthest point. Next, draw another cat ear shape or an angled "7", making sure the starting point touches the other line. Extend the line further down. Use your eraser to erase part of the back wall lines that the pillows would naturally be blocking.

Continue drawing the corners of the pillows until you've completed all four corners. Then draw in the second pillow using the same technique.

6 / Now we will draw the box frames for the planter boxes. Starting with the far left box, draw a 1-inch (2.5-cm) square box about a ¼ inch (0.6 cm) in from the wall. Make sure that the base of the box lines up with the bottom of the bench.

Then for the trio grouping, draw the left box at 1 inch wide by 1 inch tall (2.5 x 2.5 cm), aligning the square to the right side of the wall. The far right box is 1 inch wide by ¾ inch tall (2.5 x 1.9 cm). Position the center box exactly in between the left and right box and draw a ¾-inch (1.9-cm) square box.

7/ Starting on the far left planter box, draw a horizontal line about ¹⁄₁₆ inch (0.2 cm) from the top of the box to show the lip of the planter box. About ¾ inch (1.9 cm) down, draw two horizontal lines roughly ¹⁄₁₆ inch (0.2 cm) apart. Then draw a curve on each corner to round out the base of the planter box.

Next, move on to the grouping of three boxes. On the left box, starting from the corner, draw a diagonal line slanted in ¼ inch (0.6 cm) to the base. Then draw a horizontal line measuring ¹⁄₁₆ inch (0.2 cm) from the base of the box. On the far right, start from the corner of the box and curve your line coming in ¼ inch toward the middle of the box. For reference, I drew a dotted curve on the left side of the box so it matches the right side curve. Ultimately you will only see the top left corner since the center planter will be in front of it.

Moving on to the center box, start at the top of the box and draw a horizontal line ⅛ inch (0.3 cm) down from the top. From the corners of each side, draw an angled line coming in toward the center about ¼ inch (0.6 cm) from the left side. Mirror the diagonal line on the right side. Then, measuring ⅛ inch (0.3 cm) up from the base, draw a horizontal line to complete the center planter base.

8/ Starting with the succulent in the center box, draw pointed leaf shape patterns. Draw the center leaf first, starting at its base. The leaf should be ⅜ inch (1 cm) high. Continue to draw the left leaf at a 45-degree angle to the left and complete the right side leaf at a 45-degree angle leaning toward the right. You should have three leaves in total.

Next, continue to draw the top part of the pointed leaf in between the first and middle leaf as though it is peaking from behind. Then draw the final leaf in between the middle and third leaf. This completes the succulent plant pattern.

9/ Now we will draw in the cactus arms by starting in the middle of the planter first. The arms look like a loaf of bread with a dimension of ⅜ inch wide by ¼ inch tall (1 x 0.6 cm). Next, rotate to the right 45 degrees and add your next arm. The length is roughly ½ inch wide by ⅜ inch tall (1.3 x 1 cm). Next draw a longer arm, roughly ¾ inch (1.9 cm) centered in between the first two cactus arms.

These measurements are guide points, so feel free to size them as close to these as possible. They do not need to be exact. Just keep in mind that some arms can widen out while others are thin and slender.

10/ Next draw a 1-inch (2.5-cm) cactus arm tilted 45 degrees to the left. Add a ¼-inch (0.6-cm) high arm above the previous arm.

Continue adding four more cactus arms to the right side to balance out the cactus plant. Draw a ⅝-inch (1.6-cm) arm, 45 degrees to the left. Then add three more long loops behind the previous arms. Try to vary the lengths with ½ inch (1.3 cm) on the left and ½ inch (1.3 cm) on the right. The middle arm measures ¾ inch (1.9 cm).

11/ Moving to the far left planter, find the middle of the planter box and draw a ½-inch (1.3-cm) long cactus arm rotated 45 degrees to the right. Then, in the opposite direction, draw a 1-inch (2.5-cm) arm, 45 degrees to the left. Add two long ears ½ inch (1.3 cm) long on top of that.

Repeat by drawing a 1-inch (2.5-cm) long cactus arm. You do not need to position it perfectly straight. Add two ears behind that, making them irregular shaped and not the same. In nature, cacti and plants all have different sizes and shapes, so you'll want to vary the size and shapes so that they look more natural.

12/ Moving on to our last plant, we'll draw in our spider plant. Draw long sweeping arms roughly 1 inch (2.5 cm) in length and create a curved hook or bend at the end, making sure they come to a point at the tip. Angle the right leaf 45 degrees to the right. Create a second leaf angled 45 degrees to the left.

Now to fill our spider plant in, draw elongated leaves in between the hooked leaves. Some can be long and narrow while others can have a curve in them. The long and narrow leaves can range from 1¼ inches (3.2 cm) to 1 inch (2.5 cm) in length. Add another bent leaf on the far left side measuring ½ inch (1.3 cm). Create the bent hook and extend it ½ inch (1.3 cm) to the tip.

13/ Now that we've completed our sketch, use your eraser to erase the midpoint of the back wall and the planter box outer frame. Since the middle container in the trio sits in front of the other two planter boxes, erase the dark lines leaving the front container details intact. Moving up from the cactus, erase all the lines that run through the cactus arms. Move on to the far left planter and carefully erase the back wall corner on the planter box as well as the planter box frame left and right corners. The centerline on the bench should also be erased. Take your kneaded eraser and pull off any dark sketch lines, as you'll want to start with a light sketch before you color.

14/ It's time to color! Starting with a light shade of yellow (YG00), use the brush end of the marker and color in the pillows, spider plant, and larger planter box. Color in one direction, starting at the top of the pillowcase and down to the base of the pillow. Then, start at the top of the planter box and color down toward the base, lift off and reapply in the same direction. For the spider plant, start at the base of the leaf and feather up toward the end of the leaf.

15/ Next, choose a slightly darker shade of yellow (Y11) and color on the left and bottom side of the pillows forming an "L" shape. Next, color in a rounded "L" on the planter box. Using midtones shows the midtone shadows of our objects.

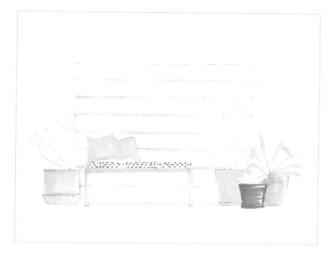
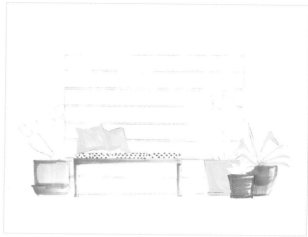

16/ Next, using a light brown (E31), color in the bench seat in a horizontal motion, gliding across the seat of the bench. Color in the legs by starting at the top and coloring downward, leaving a bit of white on the right side of the leg. I've decided the light is coming from the right side. Then, moving on to the far left planter, start at the top of the planter box and glide your marker down toward the base, remembering to leave a bit of white space on the right side. Go over the left side of the base with another layer of the same marker (E31) to darken the edge. This creates the midtone without having to change your marker color. Next, color in the spider plant's planter box, starting at the top and curving down to the base. You'll want to match the stroke to the edge of your planter. Remember to leave a little white space on the right side of the planter. Since it's a barrel shape, color in horizontal curved lines on the planter vase. Go over it again with a second layer to create midtone shadows at the edge where the center vase runs into the barrel vase.

Now let's create a pattern on the bench cushions. Choose an orange color (YR16). Using the brush end, create the polka dot pattern (make sure to only add polka dots on the cushions, not between the next cushion). Next, color the succulent's vase by outlining the planter box and then coloring in horizontal lines, leaving some white space on the right edge.

17/ Add the second layer to your brown planter boxes (E33). Starting on the far left planter box, use the brush end of your marker to color in the top lip with a horizontal line; color in a slight curve. Right before the bottom lip, color a horizontal line before the bottom edge of the planter box. As you move to the base of the planter box, color from left to right leaving a bit of white space for highlight.

On the bench, starting from the left, glide your marker (E33) in a quick motion to the right and lift off the paper about ¾ of the way through the end of the bench seat. Color a vertical line on the left side of each bench leg.

Now, moving toward the far right planter box, outline the entire brown planter box. Starting at the top, create strokes down the side of the planter box. Overlap horizontal curved lines over the previous layer.

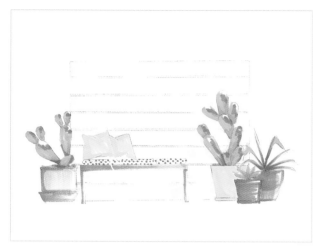

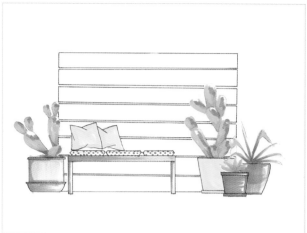

18/ Fill in the colors of the plants according to the planter arrangement lesson (pages 43 to 45).

Choose a light tan (E50) to color the back wall. Using the brush end of the marker, start from the left and glide the marker across the entire board, leaving a bit of white on the right side of the plank wall. Continue working plank-by-plank, coloring from left to right with medium pressure on your marker.

19/ Now for our final touch! Use a black detail pen (01) and your ruler to outline the back wall. Start from the top and work your way down each plank board. Keep a consistent pressure on the black pen detail.

Continue outlining your bench and pillows. Using your ruler, outline the outer cushions.

Keep a steady flow and medium pressure on the black pen.

Next, outline your planter vases using your ruler. Take your time during this delicate process.

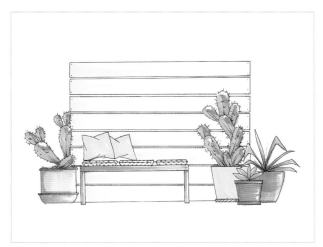

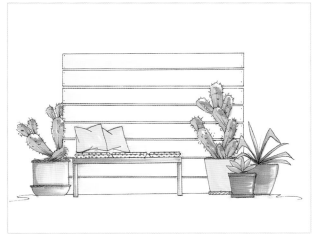

20/ Let's work on our details! Using a fine black detail pen (005), outline your cactus in a jagged edge. Add spikes by creating stipples and dash marks all around the outer parts of the cactus as well as the centers of the cactus arms. Then add two or three long lines down the center of each cactus. Don't forget to add diagonal lines on some of the planter bases to show added texture and shadow lines.

Using the same black detail pen (005), add two dots on each end of the wall plank to show nail details on the wall. These subtle details make a difference!

21/ Continue to add the same tan color (E50) on the backdrop using the broad side of the marker.

Color from the left side, and glide your marker to the right in a feathered motion. Leave lots of white space on the right to show highlight. Add an "S" or zigzag on each side of the planter boxes for a stylized sketch.

Now to add shadow! Using a cool gray (C2), add color outlining the entire outer bench, around the outer pillows, the base of the planter vases, and around the cactus where it meets the wall. Use the gray under the planter box and the "S" and zigzag on each side of the planter box. Adding the gray gives the illusion of shadow. And there you have it, your very own garden scene to help inspire your next creation!

IV.
TRAVEL AND
LEISURE

Combine Structure and Loose Sketches to Form a Scene

Inspiration often comes to me when I'm traveling or vacationing with family. It's the time that I treasure most. I've included lessons in this chapter to remind me to do more of it. I hope that during your travels you'll get inspired to sketch art pieces to share with your family and friends! I can't wait to see where this journey takes you!

PARISIAN PÂTISSERIE

My first time in Paris resulted in an impromptu "sweets tour" that my husband and I decided to create on our own. When in Paris, make sure to visit as many patisserie shops as possible! And that is exactly what we did! I love that sketching is also a way for me to document my travels, and I hope this lesson inspires you to do the same!

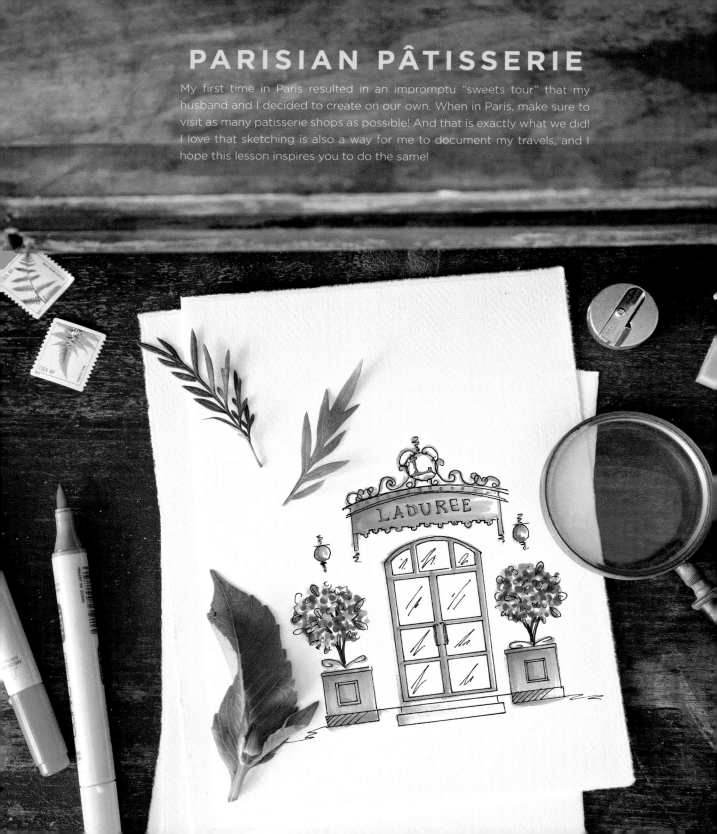

MATERIALS

- 8½ x 11-inch (21.6 x 28-cm) paper or sketchbook or 5 x 7-inch (12.5 x 18-cm) notecard
- Mechanical pencil
- Kneaded eraser
- Clear ruler
- Black detail pen 01/005
- Gold gel pen

SUGGESTED COPIC MARKERS

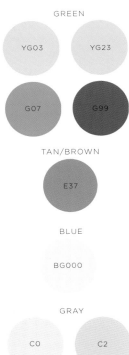

GREEN

YG03 YG23

G07 G99

TAN/BROWN

E37

BLUE

BG000

GRAY

C0 C2

1/ Draw a 4-inch (10-cm) wide baseline at least ¾ inch (1.9 cm) above the edge of the paper. Find the midpoint on the line and draw a 6-inch (15.2-cm) tall line down the center of the baseline.

2/ Now it's time to frame out our scene! Start ⅛ inch (0.3 cm) above the baseline and draw your largest center box (1½ inches wide by 2½ inches tall [3.8 x 6.4 cm]). Make sure to use your centerline and place the box directly in the center of the line. Measure ½ inch (1.3 cm) away from the doorframe and ¼ inch (0.6 cm) below the baseline. Draw two boxes, measuring ¾ inch wide by 1 inch tall (1.9 x 2.5 cm), on either side of the baseline. These will be our planter boxes!

Draw a 1-inch (2.5-cm) diameter circle ⅜ inch (1 cm) above each planter box for our topiaries. Then draw two smaller circles, roughly ¼ inch (0.6 cm) in diameter and ½ inch (1.3 cm) above the topiaries. These will be our lights.

Next, create a box that is 2¼ inches wide by ⅝ inch tall (5.7 x 1.6 cm). Center this box exactly on the centerline and ¼ inch (0.6 cm) above the doorframe. This will be our Laduree awning.

3/ Next, start from the top and draw a ½-inch (1.3-cm) diameter circle, ⅛ inch (0.3 cm) above the awning.

Since the top of the awning is curved, start by making a mark at ⅛ inch (0.3 cm) on the far left of the box. Do the same on the right side. These marks will help to guide you when you draw the curve in the next step.

Moving slowly, start your curve on the left side and a little bit outside of the awning box. Curves are tricky, so take your time.

4/ Add the second curved line underneath the first. Try to create one solid curved line instead of small sketchy lines. Remember to draw lightly. Moving down to the planter boxes, measure ⅛ inch (0.3 cm) and draw a horizontal line.

Find the center of the planters and draw a roughly ⅜-inch (1-cm) square using the centerline as your reference point. It is not crucial to have identical squares, but try to make them as similar as possible.

TIP: To draw curves, lay your palm flat on the page and let your palm glide on the paper rather than moving the pencil. This may make a smoother curve.

5/ Now to add windows. Using your ruler, measure ⅝ inch (1.6 cm) from the top of the doorframe. Start with the left window and draw a ½-inch-wide x ¾-inch-tall (1.3 x 1.9-cm) high box. Next, draw in the same box on the right side, with a spacing of ⅛ inch (0.3 cm). Use the centerline to get the size and proportions spaced as evenly as possible.

TIP: Don't spend too much time getting the boxes exactly equal; with this style illustration there's a little bit of leeway for less precision.

6/ Draw in the rest of the windows, starting from left to right. Draw a ½-inch-wide by ½-inch-tall (1.3 x 1.3-cm) box aligned below the first window. Draw another ½-inch-wide by ½-inch-tall (1.3 x 1.3-cm) box on the right. Try to keep the windows evenly spaced for the next row of windows. Draw another set of boxes on the left and right side with the remaining space.

Draw squiggly lines above and below the light. These are quick movements, and you can make the top squiggly lines thinner than the bottom. Next, draw a curve near the top of the doorframe. Take your time during this step.

7/ Next, we'll draw in the top windows on the doorframe starting with the middle window first. Using the centerline at your midpoint, draw a ½-inch (1.3-cm) window. Draw in only three sides of each window, spacing them ⅟₁₆ to ³⁄₁₆ inch (0.2 to 0.5 cm) apart. Use your ruler to line up the outer windows with the ones previously drawn. I tend to stop measuring once I have other guide points that I can use.

Draw in the top parts of the curved windows. Take your time and make sure the space is as even as possible on all the windowpanes.

8/ Next, we will add dimension and texture to our topiary. To do this, add rounded leaves, center veins and squiggly lines inside of the circle. Leave plenty of negative space so we can color in! Move quickly through this step. Some leaves can go outside of the circles. Make sure to rotate some of the leaves so they are not all drawn in one direction. Next, in the left planter, draw in a "V" shape for our branches, connecting our planter base to the tops of our topiary. Add a smaller "V" inside the larger "V" to give thickness to our branches. Add a horizontal hook at the top of the planter and one on the other side of the planter. Mirror this for the right side planter.

 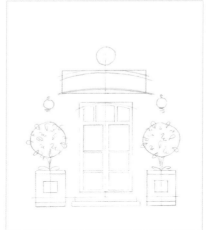 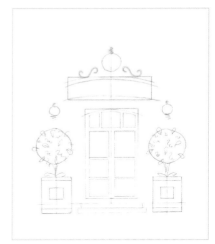

9/ Draw a horizontal line ⅛ inch (0.3 cm) from the base to give our planter box a lip. Next, to create the first step of our staircase, draw a rectangle 1⅝ inches wide by ⅛ inch tall (4.1 x 0.3 cm). Use the centerline to center the rectangle.

To complete the last staircase step, draw a rectangle 1⅞ inches wide by ⅛ inch tall (4.8 x 0.3 cm). Use the centerline to center the rectangle.

10/ To complete your awning, place a dot about ⅛ inch (0.3 cm) from the bottom of the box and on the centerline as a guideline. Next, at the corner of the box, start your curved line to intersect the point you made. Gently glide your pencil to complete the right side of the curve, going past the right corner of the box.

11/ Let's add in scrolls! We'll take this step by step. Start by adding a squiggly line at the top of the circle. Next, draw an angled "S" on either side of the awning. The length should be no more than ½ inch (1.3 cm).

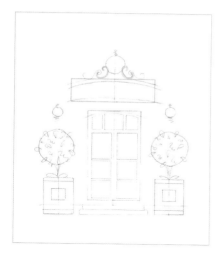 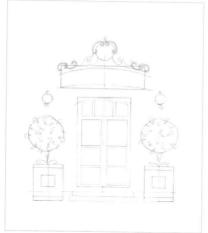 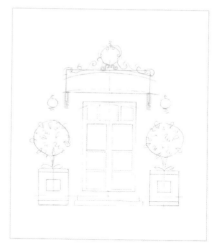

12/ The next shape resembles an exaggerated backward "C", with the ends curving in more than normal. Create an angled "C" on each side of the center circle, about ⅜ inch (1 cm) in length. The ends of the "S" and "C" hook into each other.

After plenty of practice, you'll be able to "eyeball" the measurements without having to measure each object. The more you practice, the faster you'll become at figuring out scale and proportion.

13/ Start at the far left of the awning and draw a "C". This time the "C" is laying down on top of the awning. Continue drawing another one on the right side. The size is about a ¼ inch (0.6 cm) in length. The next set looks like exaggerated ears. Make sure to curl the ends and let them sit on top of the circle.

For the next set of scrolls, draw a "C" as if it is lying on its back. Try to mirror them on each side. Make sure to overlap the scroll ends and draw exaggerated curled ends.

14/ In the last set of scrolls, draw an exaggerated "S" shape at a slight angle (less than a ¼ inch [0.6 cm]). Repeat this step on the right side and create a backward "S". Make sure to have the scrolls touch the circle and the top of the awning.

Using your ruler, draw a ¼-inch (0.6-cm) box on the left and right side of the awning. Add a small squiggly line at the bottom of each box.

TIP: For details this small, it's best to use a mechanical or a sharp pencil point.

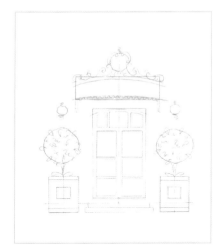 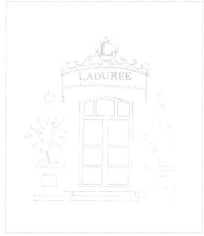 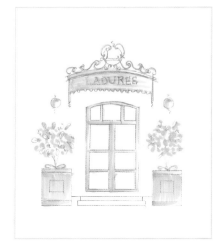

15 / Now we are going to draw in the little details at the bottom of our awning. Start with a dash and alternate with a tiny half-circle. Continue the pattern dash then half-circle all the way across the line. Don't worry about being perfect here; just try to keep the pattern consistent.

16 / Draw a horizontal line using your ruler. This will be your guideline for writing your letters on a straight line. Begin with writing in the "U" in the middle of our centerline, then write out the rest of the letters from the center outward so that you can space them out evenly. The Laduree sign is in a serif font, so don't forget to add the dashed line or footers at the ends of each letter. Using your ruler, draw an "L" in the circle. Make sure it sits on the left where it attaches to the circle. Now add thickness all around the "L". Add the dashed lines at the ends of the "L" for the serif font.

Now, erase the center guidelines, circle bounding boxes, and any other lines that will not be in the final sketch. Take your kneaded eraser and pull off any dark lines, as you will want to have a light sketch before you color.

17 / Take out your green set of markers! Start with your lightest shade first (YG03). Using the brush end, start by outlining the entire awning's edges and the scrolls. Color from left to right in a feathering motion, leaving the right side white. This shows highlights and that the source of light is coming from the right.

Next, color the lights in a crescent shape, leaving the right side white. Then, using your ruler, outline the planter boxes and doorframe. Begin to color from top down and in one direction. Make sure to lift the marker off the paper each time to start a new stroke; this keeps consistent lines as you color. For the base of the planter, color from left to right. Notice I left a bit of white on the right side here as well. Finally, stipple in greens for the topiaries and change the pressure from light to medium as you stipple to produce different sizes.

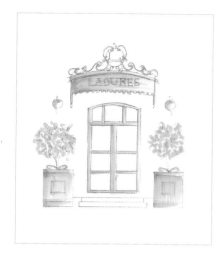 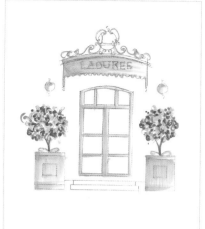 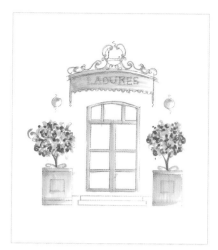

18/ Add your next layer of green! Using a slightly darker green tone (YG23) shade on the left side of all the shapes. Starting at the awning, color from left to right. Do not zigzag your marker; lift it off the page and start each new stroke.

Color in the lights with a thinner "C" or crescent shape on the left of each circle. Continue as you did in the previous step, by using your ruler and coloring over the first layer of the planter boxes and then the doorframe. Make sure that as you color, you draw a thinner line so that the first layer is visible. Add the second tone to show a little bit of shadow under the lip and base of the planter. Also color the inside of the left small square. Outline the curly detail at the top of the planter. Then stipple in more of the topiary, making sure you add thick and thin stipples to create interest.

19/ Focusing on the topiary, add a brighter green (G07). Continue to fill in the topiary using the stippling technique and adding "C" and curlycues. You will get the best results from being fast and with creating random shapes. It's okay to leave a bit of white inside of the topiary, as this shows that you can see through the plant.

Choose a more earthy or deeper green (G99). Fill in the remaining part of the topiary so it fills up the space; add more stipples and curly cues to the topiary. It's okay to go outside of the circle a bit so that it isn't perfectly circular.

Next, use a dark brown (E37) to color in the tree trunk. This is the thin line, so use the brush end of your marker and start at the base at the top of the planter and glide the marker up toward the topiary. Color in a curved "V" for the tree trunk.

20/ Now to color in the windows! Use a light sky blue (BG000) to color in the windows. Using the broad tip, place the tip flat on the paper and draw in a diagonal zigzag pattern. It's okay that there are white areas on the window. Color in a diagonal pattern on the windows consistently on each window frame. Keeping your marker strokes consistent creates a cohesive pattern on the final sketch.

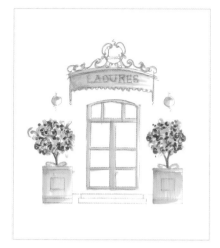
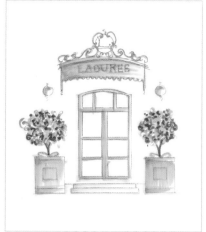
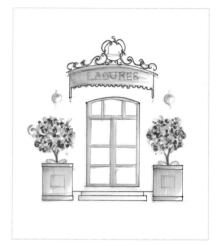

21/ To add shadowing on all of your shapes, start with a light gray (C0) and use the brush end to outline only on the left side of the awning, scrolls, light fixtures, doorframe, planter boxes, and topiaries. Fill in from the left to right in a horizontal stroke on the entire staircase, leaving a bit of white on the right side for highlights. Remember that the light source is coming from the right side so the shadows are cast on the left of the objects.

22/ Next, choose a slightly darker gray (C2) to shade over the first layer. Use the brush end to outline only on the left side of the outer awning, scrolls, light fixtures, door-frame, planter boxes, and topiaries. Again, remember that the light source is coming from the right side, so the shadows are cast on the left of the objects. On the staircase, use the edge of the marker to color in the staircase. Color from left to right in one smooth motion. At the ends of the planter, draw a zigzag line on each side to give it a little whimsical touch! Make sure that both grays are visible.

23/ Time to outline your sketch! Using the 01 black detail pen and your ruler, outline all the straight edges. Start with the planter boxes and outline the lip of the boxes. Be mindful of letting each layer air-dry before you draw the next line as it may smear if you move too quickly. Then move onto the staircase and outline that next. Proceed to outline the outer doorframe. Freehand the curve on top of the doorframe and the top and bottom of the awning. Now outline the dash-half circle pattern. Next, draw the scrolls, circle, and the squiggly line at the top of the awning.

TIP: Have a separate sheet of paper to practice drawing the curves before the final drawing. Move at a semi-quick speed since the slower you take, the thicker the line will become.

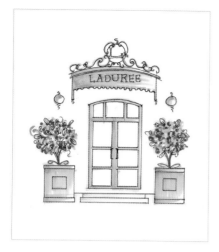
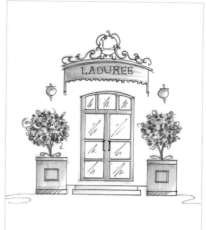
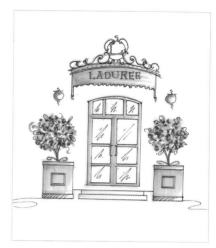

24/ Use the finer black detail pen (005) for all the delicate details. Starting with the straight edge objects first, use your ruler to draw the square inside the planter. Next outline each windowpane inside the doorframe, and add the door handles by drawing two sets of brackets starting at the top of the middle windowpane. Keep it in proper proportion; you want to think of a person opening the door and where they might pull the handle.

Next, work on the topiaries; make sure your strokes are quick, loose and feather-like for a whimsical look. Outline the rounded leaves and add the center veins. Add squiggly lines and curlycues. Stipple inside the topiaries to add texture. Create the curl above the planter.

Now, move up toward the awning, outline the "L" inside of the circle. Outline the letters "LADUREE" and don't forget to add the end lines to the serif font. Then, add the squiggly lines and circle to the lights.

25/ Create zigzag lines on your windows to give an illusion of a reflection. Begin by drawing a zigzag, starting out wide and narrowing at the base. Zigzag in a diagonal direction and place a dot at either end. Or, another way to draw reflection on a glass surface is by starting with a dashed line, then a long line in the middle, and a middle-sized line at the end. Add diagonal lines on the planter bases to create shadow and zigzag lines on the edge of your planter boxes. Keep them all in one direction so there is a pattern.

To add texture and to create illustrative shadows, add diagonal lines to the base of the planter box ledge. Begin on the left and draw lines at a 45-degree angle, start them closer in space at the start and gradually widen the space as you get toward the middle. The lines end at roughly ¾ inch (1.9 cm) across the ledge to show highlights.

26/ For the finishing touch, add the gold gel pen detail to your awning by drawing evenly spaced dots on the top curve. Fill in the letter "L" inside of the circle and write out "LADUREE," exposing a bit of the black detail line. Color in the left edge of the lighting fixtures, making sure the two green tones are still showing through. There you have it—a beautiful sketch of the iconic Laduree patisserie shop! I hope this inspires you to create your own and make your way to Paris!

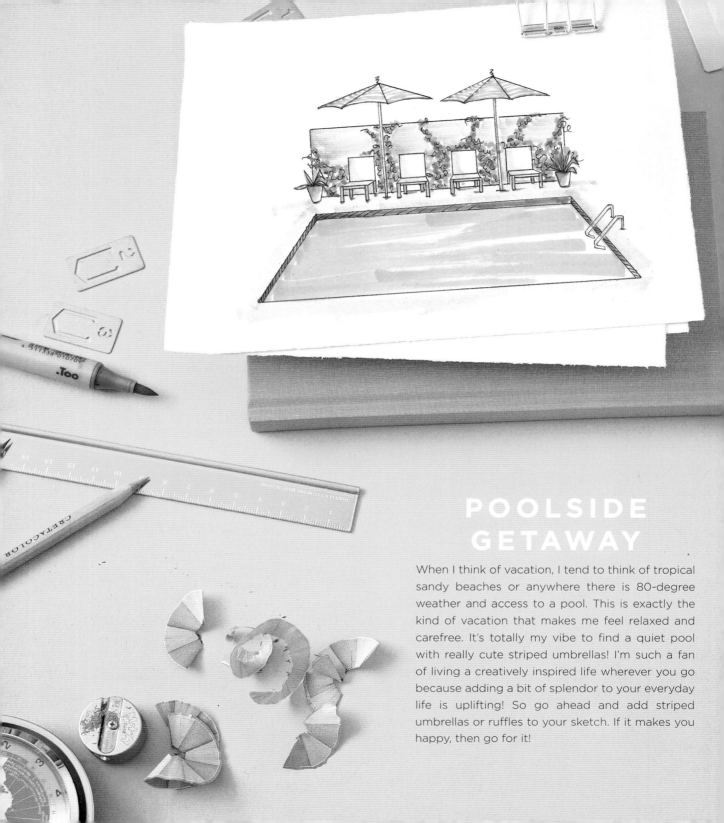

POOLSIDE GETAWAY

When I think of vacation, I tend to think of tropical sandy beaches or anywhere there is 80-degree weather and access to a pool. This is exactly the kind of vacation that makes me feel relaxed and carefree. It's totally my vibe to find a quiet pool with really cute striped umbrellas! I'm such a fan of living a creatively inspired life wherever you go because adding a bit of splendor to your everyday life is uplifting! So go ahead and add striped umbrellas or ruffles to your sketch. If it makes you happy, then go for it!

MATERIALS

- 8½ x 11-inch (21.6 x 28-cm) paper/sketch-book or 5 x 7-inch (12.5 x 18-cm) notecard
- Mechanical or #2 pencil
- Kneaded eraser
- Clear ruler
- Black detail pen 01/005

SUGGESTED COPIC MARKERS

GREEN

YG03 YG23 YG63

BLUE

BG000 B12

BROWN/TAN

E31

PINK/RED

RV42 YR61

GRAY

C2 N4

1/ Start out by drawing a 6-inch (15-cm) baseline about 1 inch (2.5 cm) from the bottom of the page. Next, find the midpoint and draw a 7-inch (17.8-cm) vertical line.

Measure up 1⅜ inches (3.5 cm) from the baseline and draw a 4-inch (10.2-cm) horizontal line for the top of the pool.

2 / Next, take your ruler and connect the ends of each line so that they form a diagonal line on both sides of the pool. This will give you a perspective as though you are standing over the pool but still able to look straight ahead.

3 / Next, we will draw 4 squares for the backs of the poolchairs. Use the centerline to find the middle and measure ⅜ inch (1 cm) out for the first square. Start the squares ½ inch (1.3 cm) above the top line of the pool. Each box is ⅜ inch by ⅜ inch (1 x 1 cm) and spaced out ⅜ inch (1 cm) apart. Mirror this for the other chairs.

Now to draw your seats: measure down ⅛ inch (0.3 cm) from the bottoms of the chair backs and draw a line ½ inch wide (1.3 cm) for the chair seat base. For the center chairs, try to draw the lines centered to the chair backs. For the far right chair seat, draw the ½-inch (1.3-cm) line slightly to the right of the chair back. And for the far left chair, draw a ½-inch (1.3-cm) line slightly to the left, no more than ⅛ inch (0.3 cm) past the chair back. Draw the angled lines to complete the chair seat. Similar to the concept of the pool, draw in the angled lines and connect the top line with the bottom line.

4/ Now add legs to your chairs! Draw the two front legs on each side of the chairs measuring ¹⁄₁₆ inch wide by ¼ inch tall (0.2 x 0.6 cm). Make sure the legs are right at the edge of each chair. Using your ruler, measure ¼ inch (0.6 cm) below the bottom edge of the chair back and draw dashed lines to the end of the back legs. Since the back legs are small, I freehand the back legs to match the width of the front legs. The two chairs in the center will have legs inside of the front two legs. Next, move on to the right chair, draw one of the back legs at the corner where the chair seat and chair back meet. Draw in the last leg on the opposite corner where the chair seat and back meet. Mirror this for the other chairs.

Draw a horizontal line ¹⁄₁₆ inch (0.2 cm) underneath the seats to add thickness to the chair frame!

TIP: For small details, make sure you have a sharpened pencil or use a mechanical pencil.

5/ Now to add our umbrella stands, draw two 1½-inch-tall (3.8-cm) lines in between the first and second chairs. The poles should be thin, but no larger than the legs of the chairs. Next, draw two 1½-inch-tall (3.8-cm) lines between the third and fourth chairs. Draw a small dashed line at the base of the umbrella stands. Next, draw in triangles for the tops of the umbrellas using the top of the pole as the center. The width of the umbrella is 1⅞ inches wide (4.8 cm), with the point of the triangle at ⅜ inches (1 cm) high.

To draw in your background wall, add a rectangle box behind your chairs and umbrellas. Draw a 4-inch-wide by 1⅛-inch-tall (10.2 x 2.9-cm) box; use the centerline as a guide to place it on the drawing.

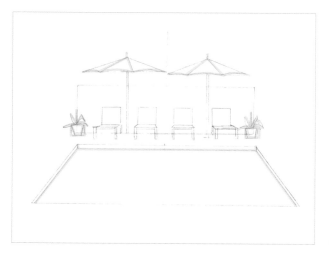
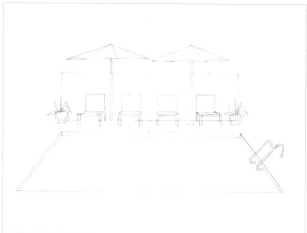

6/ To give shape to your umbrellas, add three slight curves to each. They do not need even spacing.

Draw in the details of the umbrellas by adding straight lines going from the top to the low points of the curves. Add squiggly lines at the top of the umbrellas to show the detail of the umbrella spindle.

Using our spider plant lesson (page 42), add in a box and build out plants on the right and left side of your rectangle.

Add thickness and dimension to your pool by drawing a thin horizontal line, ⅛ inch (0.3 cm) below the top of your pool line. Draw in vertical lines at the ends to close the rectangle.

Add thin lines extending out from the sides of your pool. Keep the lines parallel from the first lines.

7/ Place your ruler on the angle of the pool and mark off ½ inch (1.3 cm) to start the first rail placement. The entire rail should be ⅝ inch (1.6 cm) in length. Draw a ½-inch (1.3-cm) line roughly at a 45-degree angle. For placement, ¾ of the rail sits above the pool. Add in curved brackets on each end.

The front rail is spaced out a ¼ inch (0.6 cm) away from the previous line. The entire length of this rail is ¾ inch (1 cm). Continue to draw a ⅝-inch (1.6-cm) line at a 45-degree angle, making sure both angles are parallel to each other. For placement, ¾ inch (1 cm) of the rails sit above the pool. Add in curved brackets on each end and add thickness to the rail, no more than ⅛ inch (0.3 cm) thick. At the top where the rail meets the floor, draw a dashed line.

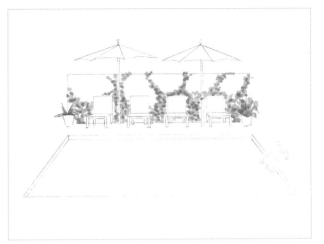
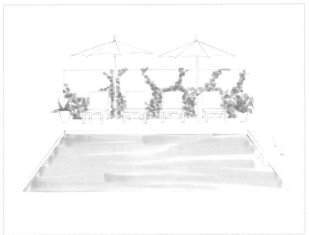

8/ Before we start coloring, erase the centerline. Use your kneaded eraser to pull off any dark lines you may have. Now let the fun begin! Start with the lightest shade of green (YG03). Using the stippling pattern (page 149), stipple in the greenery on the back wall and the plants. The dots should be in a random pattern.

Continue stippling with your second tone of green (YG23), which should be a few shades darker than the first green. Stipple in more greenery on top of the first layer on the vines as well as coloring in the spider leaves.

Using the darkest shade of green (YG63), continue to add more texture in the areas where there would be shadows. For example, the spider plants might cast a shadow on the wall behind it.

9/ Time to color in the pool! Using your light blue shade (BG000), color in the entire surface of the pool. Start on the left side, lay the broad side of the marker tip flat on the paper. Next, create a smooth and swift line while pulling off the paper as you get to the opposite side of the pool. It's a quick glide-and-pull motion as if you are painting on the paper. Color in one direction and leave a bit of white space throughout the pool.

Take your slightly darker shade of blue (B12) and color on top of the first layer. This time use the brush side of the marker to give an illusion of texture in the water. Turn your marker at a 45-degree angle and lightly feather in your color. Leaving a bit of white space is ok!

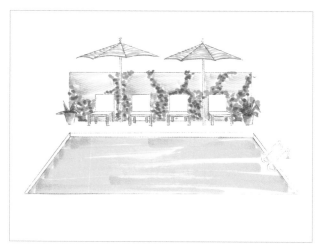 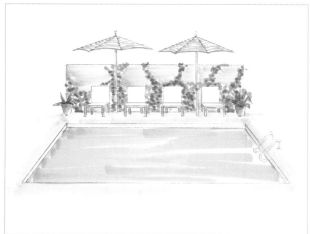

10/ Color the back wall by using a light tan (E31). Using the brush end, color in from the left and drag the marker to the right. Do not let the marker sit on the paper, as it will bleed through. Once the marker dries, go over areas along the edge of the greenery with the same color (E31) and darken the edge to show a shadow that is being cast from the vines. Also color in each of the legs. Since the legs are small areas, use the very tip of your marker to color these in.

Let's add detail to the umbrellas! Using the brush end of RV42, loosen the grip and draw thin lines to create stripes on the umbrellas. Follow the curve of the umbrellas to draw the stripes.

Color in the planters with YR61, leaving a bit of white on the right side for highlights.

Color over it with a bit darker shade (RV42). This will add dimension to your object. Make sure to allow the first color to peek through.

11/ Use a light gray (C2) to color the floor around the pool. Using the brush end of the marker, start at the top near the base of the chairs and glide the marker in between all the legs. In larger surfaces, color using one solid and consistent stroke. Move in a clockwise pattern, down the right edge of the pool (coloring from top to bottom). Then going from left to right, color in the front of the pool. Lastly, from the top left corner, glide your marker (C2) down the edge of the pool.

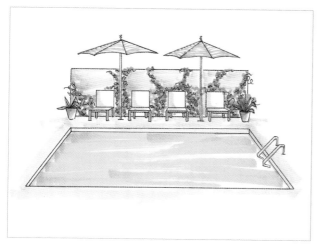

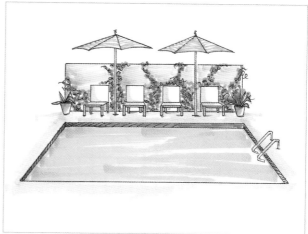

12/ You're ready to outline your details! Use a black detail pen (01) to start outlining the pool, chairs, background, and plants. Don't forget to use your ruler! I suggest starting with all the straight edges first so that you can start to see all the structural pieces.

Next, outline the umbrellas using the ruler. Outline the outer triangle and then the inside seams. Add in the squiggly finial tops of the umbrellas.

Use a thinner black detail pen (005) to color in the greenery. Using squiggly lines and curlycues (pages 149) fill in the green areas. Don't over fill! If there are areas that look flat or don't have enough contrast between the green tones, then add more color. Add in gray color (C2) on the left side of the white chairs to show shadows. Color in rounded "L" shapes on the seats, leaving a bit of white on the right sides of the seat.

13/ With the brush end, add a darker shade of gray (N4) to the edge of the pool, at the bottoms of the chair legs, and plant bases. Adding this darker shade of gray adds more interest to your final sketch.

Using a fine black detail pen (005), add diagonal lines to the edges of the pool. This adds more texture to your drawing. There you have it, a scene from your poolside getaway!

MAJESTIC DESERT GLAMPING

I'm always on the lookout for the next big adventure! I love the outdoors, especially camping. There's always so much to look at, whether it's the mountains in the far-off distance, cool cacti and plants, or even the camper you arrive in! I've always loved the idea of sketching my travels as a postcard or little "Thinking of You" card to send to my family and friends. I hope that this lesson inspires you to not only plan your next adventure, but also to find time to send to your loved ones a little memento of your recent trip!

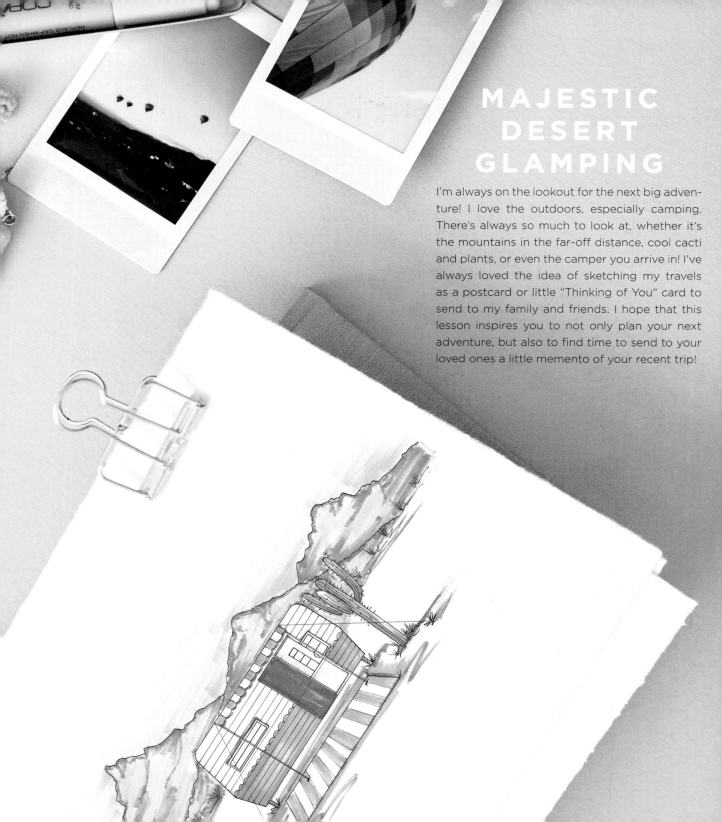

MATERIALS

- Sketchbook, sketchpad at least 8½ x 11 inches (21.6 x 28 cm)
- Mechanical or #2 pencil
- Kneaded eraser
- Clear ruler
- Black detail pen 01/005
- Gray Le Pen

SUGGESTED COPIC MARKERS

TAN/BROWN

E31 E33

PINK/RED

YR61 R02

BLUE

BG000 BG23 BG34

GREEN

YG23 G14

GRAY

C0 N4

1/ Start with an 8½-inch-wide by 11-inch-tall (21.6 x 28-cm) piece of sketch paper or sketchpad. Turn your paper to the horizontal view, where the page is longer lengthwise. Using your ruler, draw a horizontal line in the middle of the page across the entire paper. This is called the horizon line. Next, divide the paper in half and draw a vertical line in the middle of the horizon line.

2 / Draw a rectangle box 4 inches wide by 2 inches tall (10.2 x 5.1 cm). This is going to be our glamping mobile! Bring the box about a third of the way down below the horizon line. The width of the box needs to be even on both the left and right sides.

3 / Now to draw your background mountain scene! For the central mountain, lightly sketch a jagged edge mountain. Don't worry if the mountain is not exactly on the centerline.

Add in the left mountain, with rougher and more jagged edges. Make the peak higher than the first mountain.

Then add the right mountain, making it slightly lower than the previous two. By adding in varied heights and textures, the background looks much more realistic. You do not want every mountain to look exactly the same. Continue to make jagged edges for the mountain tops.

Roughly ¼ inch (0.6 cm) up from the bottom of the small box, draw a horizontal line. This will be the height of the glamping camper stakes or legs.

4/ Now it is time to frame your glamping camper. Make sure your pencil has a sharp point. On the right side, draw a dot at ¾ inch (1.9 cm) below the horizon line. On the left side, mark a dot at 1 inch (2.5 cm) below the horizon line. Using your ruler, draw a diagonal line from the point to the base toward the outside camper.

Create a diagonal line from the top of the box to the previous point and round out the corner of the box.

Create a rounded corner on the top right side of your box.

5/ Now draw rectangles for your windows/doors. Keep in mind the positioning and use the centerline as your reference point. Imagine the door of the camper is propped open. Start by drawing a ½-inch-wide by 1½-inch-tall (3.8 x 1.3-cm) rectangle for the doorway. Draw the same size box to the right of the first rectangle, and draw a horizontal line a little more than one third up. This rectangle is the door. Next draw a rectangle ¼ inch wide by ½ inch tall (0.6 x 1.3 cm) next to the door for the right window. To draw the left rectangle window, measure ¼ inch (0.6 cm) left of the centerline. Using your ruler, draw a box that is 1 inch wide by ¼ inch tall (0.6 x 2.5 cm).

Next, add the details in the window/door. Using your ruler, draw a thin line around the doorframe and windows about ⅛ inch (0.3 cm) around all sides. Draw a window on the door, with the panes spaced into thirds. Divide the right window in a similar fashion.

Since this is a 2D view, meaning the object is flat, draw in two legs on the right and left. Using your ruler, draw the legs angled about 30 degrees in as they meet toward the base or ground.

6/ To draw in the awning, use your ruler and draw a 2¼ inch wide by ¼ inch tall (5.7 x 0.6-cm) rectangle. Extend the bottom of the box frame below the base of the camper on both sides; these will be our poles. Measure ⅛ inch (0.3 cm) and draw a horizontal line below the top of the box. Below the line, add evenly spaced "U"-shaped scallops.

Next, add half-circles evenly spaced on the sides of the glamping camper. Add thin lines to the poles on the left and right sides to add thickness to the poles. Add a ¼-inch (0.6-cm) horizontal line at the base of each pole to anchor the left and right poles.

7/ Add in the angled rug. In this view, by adding angled sides, it gives a 3D look to your 2D drawing. Measure the horizontal lines first. The front line should be 3½ inches (8.9 cm), and the back line is 3 inches (7.6 cm) spaced ½ inch (1.3 cm) apart. To draw the left sides of the rug, angle the top of the ruler away from the centerline.

TIP: Imagine that you are drawing a triangle for the sides of the rug. Depending on how steep the angle is, it changes the view and perspective of your rug.

8 / Add horizontal lines to the side of the glamping mobile, evenly spacing them ⅛ to ¼ inch (0.3 to 0.6 cm). These details will add character to your sketch! We need anchor points to our awning, so draw angled lines for each pole: one line angled left, and one side angled right. Using the rug as a guide, finish off where the rug ends or a bit past the rug. Stay within ¾ to 1 inch (1.9 to 2.5 cm) from the sides of the camper.

9 / Add the cactus trunk; freehand a long and elongated trunk with a rounded top. The trunk measures 2¼ inches (5.7 cm) high and ¼ inch (0.6 cm) wide. Next, add the right arm; imagine a bent elbow shape extending past the top of the center trunk. Then, draw an elongated oval to the left of the center trunk. Lastly, draw another elongated oval behind the first oval, keeping it slightly taller than the front oval.

10/ Using a mechanical or finely-sharpened pencil, draw in spikey grass. Randomly space it around the horizon line, below the mountains and around the cactus base.

> **TIP:** Choose random areas to add the grass; you want it to look spontaneous rather than arranged in perfectly even spaces.

11/ Add in the stripes to the shade awning and on the rug. Erase the centerline, leaving behind only what you want to color in. Take your kneaded eraser and pull off the dark/heavy lines. You always want to end up with a light sketch before you color.

> **TIP:** Since our rug is in perspective, the line in the center will be straight. The two on the side will gradually angle out as you get to the edge of the rug. Since the awning is 2D, the lines will remain straight.

12/ Time to color! Let's start with the mountains first. Choose a light tan/brown color (E31) and outline the mountains in the background first with the brush end.

Next, fill in the mountains with the same color (E31).

> **TIPS:** Color in one direction, starting from left to right in a feathered motion. Try not to let the marker sit on the paper as it will bleed through and color in only one layer and let air-dry. Leave a little bit of white space in between some lines and on the right sides of the mountains to show highlights.

13/ Next, we'll contour our mountains. This step takes a bit of imagination. For coloring in the edges of the mountains, use the brush end of the marker and slightly darker shade (E33); you'll want to create the side of the mountain by drawing bumpy or rocky edges. Alternate between thick and thin lines by easing up on the grip. Start by outlining the mountain as you did in step 12.

> **TIP:** Have a photo of a mountain or take a photo from your phone and try to recreate the mountain terrain with the marker. It's always good to have reference images when you are sketching.

14/ Now to color in our majestic skyline! Use any light color you'd like for a soft peach sunset tone. I used YR61.

I wanted the skyline to gradually go to a light sky blue, so I chose two complementary colors. Using BG000, I colored the remaining part of the sky using the broad or chiseled end.

> **TIP:** Using the broad end, color in the background. Do not zigzag, but color from the edge of the mountain outward; start and end by picking up the marker and then applying color.

15/ Now to color our glamping camper! Start with the lightest shade of aqua (BG23), but feel free to choose a light shade of your choice. Outline the color using the brush end and then fill in.

Next, using the darker shade (BG34), color in on the left side to show a shadow effect.

Color in the shade awning, alternating the stripes using R02.

Next color in the rug stripes, alternating the colors using the brush end of R02.

16/ Color in the cactus with YG23, using the brush end of the marker. Remember to always start with the lightest shade first. Use feathering strokes and make sure you do not let the marker sit on the paper. For the grass around the rug, outline the rug and color in horizontal lines on the right side of the rug. I leave a little bit to the imagination, so I don't color the whole ground in green. In this case, I want my focal point to be the glamping camper.

17/ Using a midtone of green (G14), color the left side of the cactus to show a shadow effect. Leave a bit of white space on the tip of the cactus arm and on some spots on the cactus to show highlight. Continue to use the feathering motion on the grass texture.

> **TIP:** To add character to your sketch, use zigzag or "S"-shaped markings on the edges of objects. It's a stylized way to add a shadow on the ground. I added it at the edges of the rug, at the base of the camper legs, below a few of the grass textures, and around the cactus base.

18/ To add shadows, choose a light shade of gray (C0). Using the brush end, apply light pressure to the base near the cactus. Extend the shadows toward the opposite direction where the light source is coming. Next, choose three sides of the window to outline outside of the window frame. Imagine the light source is coming from one direction and leave that side without shadow. Other areas you can add shadow to are around the rug and underneath the legs of the camper.

19/ Next, you'll want to color in darker shadows. Use a darker gray tone (N4) and color in the base of the cactus; around the windowpane; underneath the awning scallops; the doorway; the camper legs; and around the rug. Using the brush tip, delicately layer your color on top of the first gray tone.

Since we're in the palm desert with more dirt than grass, choose a brown (E33) to add the ground cover around the grass and the base of the mountains. Draw in a quick "Z" stroke to give it a stylized look.

20/ To finish, add a black outline around your objects. This helps to make the images stand out. Using a 01 black detail pen, outline the background first. Using light pressure, add jagged edges to outline the mountain tops. Using your ruler, outline the rug. Continue outlining the camper and the cactus. Take your time through this step, as it is permanent.

The key to creating interesting illustrations is to use thick, thin and varied lines. Using a thinner detail pen (005), outline the delicate details of the sketch. Start with the spikes on the cactus, using a flicking motion and random tick marks all over the cactus. Freehand the lines on the cactus, using light pressure. Continue with the quick feather motion and outline the grass textures. Move your hand in quick motions. Next, using your ruler, outline the stripes on the awning and the pegs that hold up the awning. Continue outlining the camper, window details, and legs details.

For added texture, add an "S" shape at the base of the mountains.

21/ Sometimes, for a more subtle line or a line that I don't want to become a focal point, I choose a gray detail pen. Outline the stripes on the rug; the lines that secure the awning; and the detail lines on the camper. Use a medium to light pressure on the pen to create a thin outline.

There you have it! Your very own glamping camper! Don't be afraid to add your own flair or get creative!

"Over the years I have learned that what is important in a dress is the woman who is wearing it."
—YVES SAINT LAURENT

HOME AND OFFICE

Building Blocks for Creating One-of-a-Kind Art

I spend most of my days either in my home or office. These are places that are personal to me and where I can add in my own personal touch. These are the places that I find comfort in, get inspired by, and celebrate! Lots of happy memories are made here. I've gathered three lessons that I hope inspire you to make your space just a little bit brighter. Perhaps they will inspire you to create beautiful artwork you can hang in your home or office!

HOME SWEET HOME

Who doesn't dream of having a place to call their own? We bought our first home recently, and it has become a special place for my family. Remodeling projects are underway, and there is room for the boys to have their bunk beds. It is such a joy seeing the boys have their own little hiding spots around the house. I thought that it would be so sweet to have housewarming invites with a hand-sketched illustration. This next lesson is an inspiration for your next housewarming invite or artwork you can frame and hang in your home!

MATERIALS

- 8½ x 11-inch (21.6 x 8-cm) paper/sketchbook or 5 x 7-inch (12.5 x 18-cm) notecard
- Mechanical or #2 pencil
- Kneaded eraser
- Clear ruler
- Black detail pen 01/005

SUGGESTED COPIC MARKERS

YELLOW

Y11 YR31

GREEN

YG03 YG23

G07 G85

BLUE

BG000

GRAY

C0 C2 C5

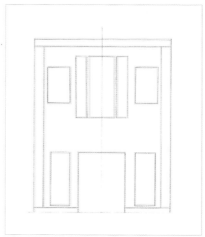

1/ Use your ruler to draw a baseline 5 inches (12.7 cm) wide. Find your midpoint and draw a vertical line 6½ inches (16.5 cm) tall.

2/ Draw a 4½-inch (11-cm) horizontal line across the top; this will be your roofline. Draw another horizontal line, ¼ inch (0.6 cm) below the roofline. Next, draw a door measuring ¾ inch wide by 2⅛ inches tall (1.9 x 5.4 cm) on each side of the centerline. Then draw your baseline ⅜ inch (1 cm) up from the base of the box. Measure ⅝ inch (1.6 cm) and draw a vertical line on the left and right side of the house.

Next, ⅛ inch (0.3 cm) from the side of the house and 1 inch (2.5 cm) below the roofline, draw a ¾-inch-wide by 1¼-inch-tall (1.9 x 3.2-cm) box on each side; these will be the side shutters. Then, draw a 1-inch-wide by 2⅛-inch-tall (2.5 x 5.4-cm) box in the middle of the two shutters. Use the midpoint line to place the box so that ½ inch (1.3 cm) is on each side of the centerline, totaling 1 inch (2.5 cm) wide. For the middle window shutters, create a box that is ⅜ inch wide x 2⅛ inches tall (1 x 5.4 cm) on each side of the middle window.

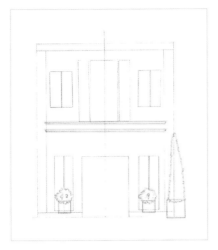 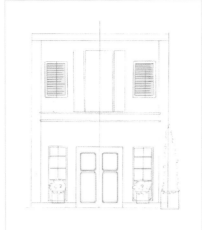 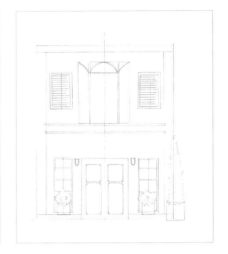

3 / Draw in boxes on each side of the door to represent planter boxes; each box should be ⅜ inch wide by ⅜ inch tall (1 x 1 cm). On top of each planter box, draw in squiggly lines to form a round shape representing a potted bush. Add squiggly lines inside of the bush for texture. Draw in a box on the right side of the house, measuring ⅝ inch wide by ⅝ inch tall (1.6 x 1.6 cm) and use the squiggly lines tapering up to shape the tree.

Next, draw a centerline on the bottom windows and side shutters. Add two trim pieces underneath the large (middle) window by drawing a 4-inch-wide by ¹⁄₁₆-inch-thick (10.2 x 0.2-cm) line centered on the midline. Extend the line about ¹⁄₁₆ inch (0.2 cm) on each side of the house. About ¼ inch (0.6 cm) below the first trim line, draw another trim line with the same measurements and extending ¹⁄₁₆ inch (0.2 cm) on each side of the trim.

4 / Draw a thin ¹⁄₁₆-inch (0.2-cm) trim inside and a vertical line in the center of each side window box. Add horizontal lines on each of the topside windows; the lines do not have to go all the way across. Try to be as even as possible, but don't worry if they are not exact.

Moving to our bottom floor windows, draw four horizontal lines evenly spaced along the length of the window. Since the planter sits right in front of the window, you may not see the fourth line. Add boxes on the inside of the front door to create the inside frame. The top boxes measure ½ inch wide by ⅝ inch tall (1.3 x 1.6 cm), while the bottom boxes are ½ inch wide by 1¹⁄₁₆ inches tall (1.3 x 2.7 cm). Feel free to use your own measurements as well. On each corner, draw a curve for a decorative detail on the inside of the front doors.

5 / Draw a horizontal line ⅜ inch (1 cm) from the top of the 2nd floor center window. Going from left to right, draw a curve, forming the half-round window. Next, visualize the middle window shutters being open. On the left shutter, start at the left corner of the box and curve down where the hinges of the shutters meet. Mirror this curve on the right shutter.

Moving to the front door, add the light fixtures. To do this, draw a horizontal line and a long "U" shape.

6/ Finish the light fixtures by drawing a dot and a curved triangle on top of each fixture. Draw in a cross or "t" inside of the "U" shape. Add a zigzag line underneath the bottom of the "U" shape.

To show the grid lines of our middle window, add four evenly-spaced horizontal lines. Next, add five evenly-spaced vertical lines (the center line counts as one of your five lines). Then, add thin tapered legs to the planter boxes by the front windows.

Now, let's add the rooftops! At each corner, create a slight curved arch measuring about ⅜ inch (1 cm) at its apex. Since there is an illusion of a front rooftop and one behind it, draw a slight curve underneath the first roof.

Positioned in the center of the bottom trim, add a trapezoid shape: ¼ inch (0.6 cm) wide at the top, ⅛ inch (0.3 cm) wide at the bottom and ¼ inch (0.6 cm) tall.

7/ Finish off the second rooftop with a horizontal line that stops at the building.

Add scallops by drawing half-circles all the way across the roofline. Try to stay as consistent as you can.

8/ Complete your scallops on both rooftops by continuing to draw your half-circles. When starting the next layer, stagger the half-circles to fall in between the first set of loops so they are not perfectly aligned in a column.

Add pie-shaped windows inside of the curved window.

9/ Using your ruler, draw evenly-spaced horizontal lines on the far left and right of the building. They represent the siding of the house. The lines do not have to extend all the way to the side of the building.

Create the door handles on each side of the centerline by adding a thin vertical rectangle with circles at each end.

Erase all of your guidelines and details that will not be part of the final drawing, leaving behind a light sketch.

10/ Now we're ready to color! Start by choosing a light yellow (Y11). Feel free to use different colors if you'd like, but choose a light color. Start by using the brush end of your marker at the top of the building and bring your marker strokes down in one direction. Don't let the marker sit on the page, as it will bleed through. You want to use feather-like painting strokes. Notice how the markers end unevenly; you want to leave some white space/ negative space on your building. Make sure to color only the building.

> **TIP:** Always start with the lightest shade first and test out your colors on a separate piece of paper.

11/ Using a slightly darker shade of yellow (YR31), color on top of the first layer. Using the brush end of the marker, start at the top of the building and color in a feathered motion. Color in areas such as underneath the rooftop, around the outer windows and doors, and under the trim lines. Think of areas that may have a shadow being cast onto the building and color in those areas.

> **TIP:** Choose colors that are a few shades darker than the first color, but not too dark in contrast. By choosing a few shades darker, you will get a more subtle transition in color and they will blend better.

 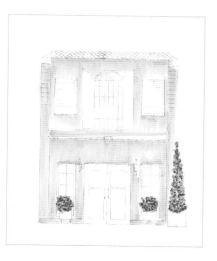

12/ If you notice that your colors show lines that need to blend better, you can use a blender marker (such as Ciao 0) so that the two colors are evenly blended for a softer look.

Choose a light shade of green (YG03). Taking the brush end and using the stipple or dotting effect, color in your ornamental bushes. Make sure to leave white space for the next set of colors.

13/ Choose a few shades darker than the first green (YG23), and stipple in additional color on top of the bushes and greenery.

Using a brighter green (G07), add more dots/stipples to your bushes. Add some squiggly lines and different size stipples to show texture.

Add your earthy tone of green (G85) to emphasize the shadows in the bushes. Use it a bit more sparingly as it is to show the shadows under the leaves.

14/ Use a light blue (BG000) and color in the windows with the brush end. Leaving a little bit of white is okay. Since the windows are small, color in one direction starting from the top of the window and lift off the marker after each stroke. Do not zigzag your marker as it may smear your pencil lines. Use the light shade of gray (C0) to color in the rooftops, from left to right. Color in the planter boxes and the legs.

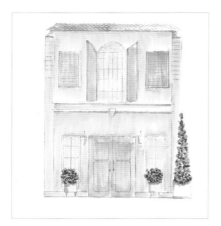 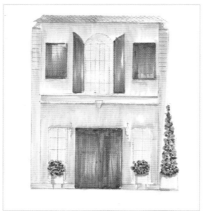 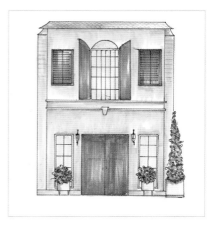

15/ Using a slightly darker gray (C2), color in your rooftops, shutters, and doors. Color from top to bottom. Add the dark gray (C2) on the left side of the planter boxes and underneath the greenery to show shadowing. Using your ruler, create a shadow line underneath the trim lines.

16/ Add a darker shade of gray (C5) to the doors and shutters. Using the brush end, outline the window shutters (on the 2nd floor) to create a border. Then fill in with color, starting from the top down. It's okay to show a little bit of the previous gray (C2). Outline the front door using a ruler and then color from top to bottom with even strokes.

17/ Using your detail pen (01) and ruler, outline all the straight edges. Start with larger shapes such as the outside of the building and work your way toward the details of the building. Draw the roof, using a steady hand on the ruler and outlining each edge. Freehand the curve of the rooftops. After each line, make sure to dry the pen by blowing softly on your paper so that you don't smear the ink. Outline the windows, trim-line, keystone, planter boxes and legs. Using light pressure, add curlycues and squiggly lines around the topiaries and greenery.

Add the windowpanes and shutters. Outline the lanterns, first with a tiny circle and then fill in the triangle. Outline the grid and add squiggly lines at the bottom of each lantern. Outline the planter boxes and legs. In the large planter, outline the lip of the base.

18/ Using a thinner detail pen (005), draw the roof scallops. Outline the horizontal lines of the house siding. Do this by imagining a line going across the entire front of the house. The horizontal siding should line up from left to right. Carefully draw in the window slices in the curved part of the window. Either use the ruler or freehand this area. Draw in the front door inset detail. Make sure to use your ruler and ink in the curved notch out of each corner. These may seem like minor details, but they add to the character of your sketch!

TIP: If you are sketching on loose paper or a card, tape down the paper using washi or masking tape so it doesn't shift around when sketching and coloring.

19/ Using your darkest shade of gray (C5), add more shadow across the top of the roof and in the inset of the doors. At this final look, you can go back and add color to areas that need evening out or more shadowing. With the 005 black detail pen, add a squiggly line on each side of your drawing for a fun detail!

20/ For texture, add in the diagonal lines at the base of the house, the middle of the house, and on the large planter base. These lines add another layer of interest to the overall sketch and resemble shadows.

There you have it, a completed house sketch! I think this would be a great housewarming card or invite. Make it personal and unique and all of your friends and family will love it!

INSPIRED DESK

What's a creative workspace without inspiration? I've come into the habit of buying myself flowers and having a space for creativity. This lesson is inspired by a space that not only keeps me feeling inspired, but also brings joy to my life. I hope this lesson inspires you to make your own inspired desk artwork to hang in your personal creative space!

MATERIALS

- 8½ x 11-inch (21.6 x 28-cm) paper/sketchbook
- Mechanical or #2 pencil
- Kneaded eraser
- Clear ruler
- Black detail pen 01/005
- Gold gel pen
- Gum paste eraser

SUGGESTED COPIC MARKERS

AQUA/BLUE/GREEN

G02 BG23 BG34

B12 B24 YG23

YELLOW

Y08

PINK/RED

RV42 R22

ORANGE

YR16

TAN/BROWN/GRAY

E31 E33 C2

1/ Start by turning your paper to portrait orientation. Draw a box measuring 6⅜ inches wide by 5 inches tall (16.2 x 12.7 cm) at least 1½ inches (3.8 cm) above the edge of the paper's edge. Since the drawers will be on the left side, measure in 2⅜ inches (6.0 cm) from the left side of the box and draw a vertical line.

2/ To draw the top of the desk, draw a horizontal line ¼ inch (0.6 cm) below the top of the box and extend the ends ¼ inch (0.6 cm) on either side so it hangs over the edge.

On the left side, draw two thin lines, measuring roughly ⅜ inch (1 cm) above the base of the box. Using your ruler, draw another horizontal line a smidge above that line.

Add lines to frame the inside of the left drawer section. Draw two vertical lines, spaced ¼ inch (0.6 cm) from the left and right sides of the drawer box. To finish the top, draw a line ⅛ inch (0.3 cm) below the tabletop.

3/ To draw the left side drawers, measure 1¼ inches (3.2 cm) from below the top of the inset frame, and draw a horizontal line. Leave about a ⅛-inch (0.3-cm) space and draw the next horizontal line. Measure 1¾ inches (4.5 cm) to the next drawer and draw a horizontal line. Leave another ⅛-inch (0.3-cm) space and draw the final horizontal line to complete the drawer frame.

To draw the right side drawer, measure ¾ inch (1.9 cm) from the bottom of the tabletop and draw a horizontal line. Measure ⅝ inch (1.6 cm) in from the right side edge of the box and draw a vertical line to help frame the desk leg.

4/ Using your ruler, draw in rectangles inside of the drawer sections; the spacing is roughly ⅛ inch (0.3 cm) from the outer edge. Draw in each drawer, starting from the top and working your way down.

Draw more rectangles inside of the previous rectangles, with ¹⁄₁₆-inch (0.2-cm) spacing.

5/ To add a drawer on the right side, draw another rectangle inside of the rectangle. Measure ⅛ inch (0.3 cm) all the way around and draw the lines of the first box. Draw the next box ⅛ inch (0.3 cm) in from the outer box.

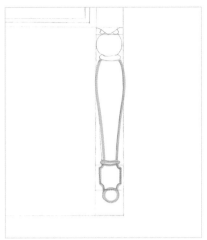

6 / This part is a bit tricky! You'll want to add lines to show the breaks all the way down the leg. Underneath the first line break, underneath where the drawer ends, measure ⅛ inch (0.3 cm) and draw a horizontal line. Next, measure ½ inch (1.3 cm) and draw a horizontal line; this will be where we add the ball of the leg. Now move to the bottom of the leg, measure ½ inch (1.3 cm) up and draw a horizontal line. Draw another horizontal line at ½ inch (1.3 cm) up from there.

Now to draw in the shapes, start at the top. In the first space, add a curve then add a circle in the next section. The circle should be a bit smaller than ½ inch (1.3 cm) in diameter.

Add a flattened oval below the circle. The oval is slightly smaller in width than the circle.

7 / Add a rounded line that starts at the top and tapers in. Mirror the line to complete the barrel part of the leg. The length of the barrel is 2⅜ inches (6 cm). The widest part of the leg should take up the width of the box. About 1 inch (2.5 cm) down is where you start tapering the leg. The thinnest part of the barrel should be about ⅜ inch (1 cm). Next, add a flattened oval to show the turns of the leg.

Draw in a rectangle roughly ⅜ inch (1 cm) wide by ½ inch (1.3 cm) high, which is the exact height of the space we created. Draw curves cut out at each corner.

Then draw a smaller circle roughly ⅜ inch (1 cm) in diameter.

8 / Add a small rectangle for the peg of the leg. Moving to the left side of the drawer, add a flattened "M" curve to finish off the bottom part of the box.

9/ I always love having flowers on my desk! Add a tall and a short floral arrangement on the right side of the table. Draw a tall rectangle ¾ inch wide by 1½ inches tall (1.9 x 3.8 cm) and a short rectangle, 1¼ inches wide by ½ inch tall (3.2 x 1.3 cm). Add fluffy clouds and squiggly lines for texture, showing fluffy flowers. Add football-shaped leaves into the arrangement, turning the leaves in different angles.

Add curves to the edge of the table by turning in the corners into the table. Add small circle knobs down the center of the left side drawers. For the drawer under the table, draw two even circles, spacing one on the left and one on the right side.

10/ Draw three rectangles in different lengths to represent books stacked on top of each other.

Draw the length of the books from 1½ to 1 ⅝ inches (3.8 to 4.1 cm) wide. Draw each of them in different lengths to show variety. We don't want them to look too perfect.

11/ Next, to add a cup, draw a ⅝-inch (1.6-cm) square box and taper in the sides of the cup.

Add a backward "C" for the cup handle and draw a smaller "c" to create the thickness of the cup handle.

Next, using your ruler, measure 2 inches (5.1 cm) from the top of the table and draw a horizontal line for the photo string, roughly the length of the table. The length should be 5¼ inches (13.3 cm) from the start of the floral arrangement. Add a ¼-inch (0.6-cm) diameter circle at the end for the anchor knob.

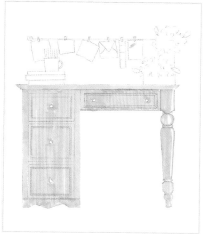

12/ To draw in the pencils, draw vertical lines coming out of the cup.

Next, it's time to let loose a bit. Freehand different sizes of paper, and add the first two squares in different sizes. Some of the shapes can be curved and some straight. Time to get a little creative! Add a small rectangle to show clips above each paper.

Continue to add envelopes, strips of paper, etc. Different sizes and shapes are great!

Erase all the reference lines, leaving behind only what you want in the final sketch. Don't forget to use the kneaded eraser to pull off any dark/heavy lines.

13/ Now time to color! Start with the lightest shade of aqua (G02) and using the broad end, color the desk starting at the top left and move down. Leave the flat end of the marker on the paper and pull down in a consistent line. Then pull the marker off the paper and move back to the top. Make sure not to zigzag, as it will leave an uneven stroke line. Leave a little sliver of white on the right side of the leg to show highlight. Add color to the hanging artwork, as well.

TIP: To determine what to color first, start with the object that will need the most color.

14/ To add a midtone to the desk, use a slightly darker tone (BG23) than the previous color. Using the brush end, color in underneath the lip of the tabletop, inset of the drawers (only two sides), the left side of the legs, and the turns and details of the legs. Add the midtone color underneath the last drawer, as well. I've decided the light is coming in from the right side.

Next, chose a third shade, typically the darkest tone (BG34), to represent shadows. Using the brush end, color in the inside of the drawer; top and left side; underneath the knobs; underneath the drawers; and in between the breaks of the desk leg. Make sure to use your ruler on those straight edges.

15/ Using a light pink (RV42), stipple color in the florals and color parts of the artwork. Leave a bit of negative space in the florals so that we can add more color in the next few steps.

Adding the midtone pink (R22) into the arrangement, continue to stipple in more color in the floral arrangement, and add more color to the artwork.

Add orange (YR16) to the florals by continuing the stippling pattern. Using the brush end, add feather like strokes to color in the envelope and artwork.

16/ Time to add color to our leaves by using a light shade of green (YG23). Start at the base of the leaf and feather toward the tip, leaving a bit of negative or white space to show highlight.

Now to add a light tan (E31) to our books and wooden floral vases! Using the brush end, color by starting on the left and gliding the marker to the right.

Don't forget to add the shadowing; choose a slightly darker shade of brown/tan (E33). Color from the left and glide the marker toward the right in a feathering motion.

17/ Add blues in different shapes and patterns of the artwork. Get creative! I went with a spiral shape with my light shade of blue (B12) and added a darker shade of blue (B24) to my color swatch.

Now, to color our pencils (Y08), choose a sunny yellow. Time to add shadow to our white mug. Using gray (C2), color the left side of the mug. Add horizontal lines underneath the desk and an "S" at the end of the right leg. Let the first layer on the mug air dry, and add another two layers of gray (C2) to darken the midtone shadows on the left side of the mug. Color in an "L" or "C" shape on the left side of the mug.

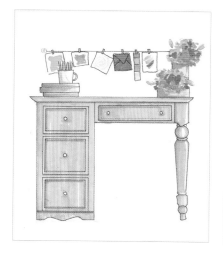
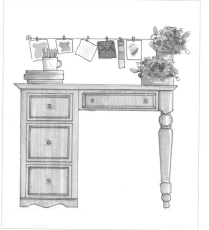
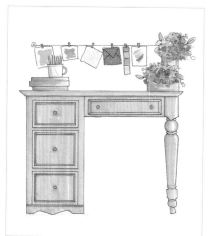

18/ Now for the final touch! Using the 01 black pen and ruler, outline all the straight edges first. Start with the largest object first and work your way down to smaller details. Start with the desktop and work your way through the drawers. Take your time through the outlining part. Next outline the table leg working through each section. You'll begin to see the table transform. Add more detail by outlining the drawer details. Next, outline the circle knobs. Continue to outline the books, then the mug and handle. Move onto the right and outline the floral vases. Next, freehand the pencils by drawing lines in different angles. Continue to outline the artwork, envelopes, and color swatches hanging above the table. Don't forget to outline the clips.

19/ To add the delicate details, use a thinner black detail pen (005). Outline the leaves and center veins. Move quickly through the arrangement. Add curlycues and squiggly lines for texture in the floral arrangement. Add the curlycues outside of the arrangement to add whimsy. Using the ruler, draw the line that is holding up the artwork, being careful not to draw the line through the art clips. Outline the circle knob of the art string.

20/ To punch up our final sketch, add a little gold gel pen to the art clips, drawer pulls, and a thin line on the mug. Add in some curlycues in the arrangement.

Lastly, it's always a good idea to let the gel pen dry before you take one final pass at erasing the pencil marks. Using the white rubber or gum paste eraser, erase the entire drawing to get rid of any leftover pencil lines.

I love this lesson because it inspires me to decorate my desk, but more importantly, I can't wait to see what you'll create!

AUTUMN MANTEL ARRANGEMENT

The mantel is a place in our home that is the focal point and a place to gather. It will be a place that serves many different scenes throughout the changing of the holidays and different celebrations. I hope this next lesson inspires you to create something amazing!

MATERIALS

- 8½ x 11-inch (21.6 x 28-cm) sketchbook or 5 x 7-inch (12.5 x 18-cm) notecard
- Mechanical pencil or #2 pencil
- Kneaded eraser
- Clear ruler
- Black detail pen 01/005/008

SUGGESTED COPIC MARKERS

GREEN

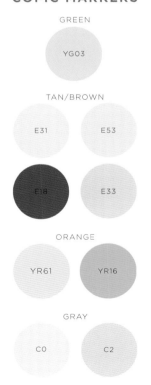

YG03

TAN/BROWN

E31

E53

E18

E33

ORANGE

YR61

YR16

GRAY

C0

C2

1/ Start by turning your paper to the portrait orientation. About halfway through your paper, draw a horizon line all the way across the sheet. Then find the midpoint of the horizontal line and draw a vertical line through the entire sheet of paper. Start with measuring a 5¾-inch-wide by ⅟₁₆-inch-tall (14.6 x 0.2-cm) rectangle below the horizontal line; make sure the left and right sides are even. Use the centerline as your guide to ensure the mantel is centered. Next, draw a 5¼-inch-wide by ⅟₁₆-inch-tall (13.3 x 0.2-cm) or smaller rectangle, centered on the centerline. Make sure that you have ¼ inch (0.6 cm) space on the left and right side; this is another way to check that your mantel is proportionately even. Lastly, add a 4¾-inch-wide by ⅟₁₆-inch-tall (12 x 0.2-cm) rectangle below the middle rectangle.

2/ Add rectangles to build out the framework. Measure ⁹⁄₁₅ inch (1.5 cm) above the mantel and draw a 3-inch-wide by 3-inch-tall (7.6 x 7.6-cm) square, centered on the centerline. This box is going to be where we draw our mirror. Next, to draw our floral arrangement, draw a 1½-inch-wide by ½-inch-tall (3.8 x 1.3-cm) box centered on the centerline. Then to draw our candlesticks, draw two tall rectangle boxes ¼ inch (0.6 cm) to the right of the centerpiece. The shorter candlestick base measures ³⁄₁₆ inch wide by ½ inch tall (0.5 x 1.3 cm), and the taller candlestick base measures ³⁄₁₆ inch wide by ¾ inch tall (0.5 x 1.9 cm).

TIP: When creating your own sketch, feel free to use your own measurements but keep in mind size and proportion so the shapes scale properly.

3 / Next, you will be drawing a circular mirror. The easiest way to do this is by dividing the large square in half and drawing a horizontal line at 1½ inches (3.8 cm) down the centerline. The lines should cross directly in the middle of the mirror frame.

4 / Draw a freehand curve starting at 9 o'clock and rotating up toward 12 o'clock positioning.

Continue to rotate the paper so that every new quadrant starts at 9 o'clock and draw your curve rotating up toward 12 o'clock. Move in a clockwise direction.

Complete the circle by rotating the paper.

Repeat the same steps to draw the inner circle. The space between the circles should be ½ inch (1.3 cm).

5 / Divide the candlesticks in half by drawing a vertical line in the middle of the two boxes.

Much like our cake stand lesson (page 150), candlesticks can be drawn with the same technique. Start at the top left and draw an upside-down half bell shape. Start with a 45-degree angle from the top left corner, draw a longer line down and cut right about 30 degrees.

6/ Draw in the second candlestick starting with the same shape as the previous step. Mirror the shape on the right half of each candlestick.

You'll want to stay close to the centerline since the candlestick is thin. Continue down the centerline by drawing a half-circle and curve out, then extend an angled line toward the bottom left corner for the base.

7/ Make your way to the taller candlestick. Start on the left side first. Curve out to form a point. From the point, curve back in toward the centerline and start a gradual curve away from the centerline. Begin to slowly bring back the curve so that it meets the centerline and will begin to flair out toward the base of the candlestick. The curves here are very subtle, so you'll want to focus on the tiniest of details to ensure the stem of the candlestick isn't too wide or dramatic.

TIP: Make sure on the micro details you have a sharp pencil point or use a mechanical pencil.

8/ To complete the other side of the candlestick, you'll want to pay close attention to the left side and mirror the shapes as accurately as possible on the right side of the centerline. Start at the base of the candlestick holder.

9/ Draw in pumpkin shapes, starting with an oval for the centers. The oval should be roughly ¼ inch (0.6 cm) long. Add ears to each side of the oval to fill out the pumpkin. Draw in two pumpkins at different angles, one over the edge of the box and one angled to the right above the arrangement box.

Next, add pointed leaves with center veins. Draw your leaves in different directions. Add different sizes and shapes; choose no more than three different shapes for this arrangement. Draw in the pumpkin stems.

Add in another variety of leaves; the one I chose has a jagged edge.

Add two thin 1¹⁄₁₆-inch (2.7-cm) tapered candles with teardrops for the flames.

10/ To add the garland, first draw one continuous curve. Starting at the left end of the rectangle floral arrangement, draw a curve with the farthest curve ⅜ inch (1 cm) down from the centerline. The second curve should be ¾ inch (1.9 cm) down from the centerline, with the start toward the edge of the mantel.

Start from the centerline and add in pointed leaves going from one direction and then the opposite direction. Notice the right leaves point toward the right side, and the left leaves point toward the left. Use the curve as a guide to draw the leaves.

11/ Add more leaves in different sizes on the second curve; this row should have slightly larger leaves than the first row. Starting from the left side of the mantel, draw the leaves heading toward the centerline.

Erase the guidelines, leaving behind the final sketch. Using the kneaded eraser, pull off the dark graphite lines, leaving behind a light sketch.

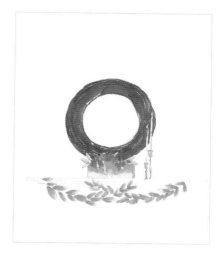

12/ Time to color our leaves. Using a light green (YG03), color in the leaves. Start coloring at the base of the leaf and thin out as you reach the tip. It's okay to leave a little white to show highlights and space for the second tone.

Since it's fall, magnolia leaves are great to hang as a garland; the leaves have a bit of brown tint to them. So, use a light tan (E31) and color over the light green. Using the brush end, start from the base of the leaves and thin out as you color toward the tips.

Chose another shade of tan (E53) to color in the round mirror with the broad tip of the marker. Place the marker flat on the paper and color in a circular pattern. Next, using the brush end, color the rectangle wood vase. Start coloring from the top of the container and pull down toward its base.

13/ Next, use a contrasting dark brown (E18), close to a mahogany color. Using the brush tip, hold the marker at a 45-degree angle and color in a counter-clockwise circular pattern. Keep the lines even and consistent all the way around the circle until the mirror is covered. Allow some of the tan (E53) color to show.

To add a bit of midtone to our vessels, choose a medium brown (E33). Using the brush end, color the candlesticks and underneath the florals, as if the leaves and pumpkins are casting a shadow over the wooden box. Start from the top of the box and lightly color down the edges.

14/ To add the base color to the pumpkins, choose a peachy color/tone (YR61). Using the brush end of the marker, color in the pumpkin. Start at the top and leave a bit of white to show highlights. Color in the candlesticks in a feathery motion.

Next, choose a darker orange tone (YR16) and layer on top of the previous peach; start with the pumpkins and then color in the autumn leaves.

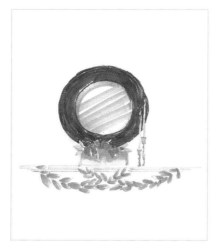
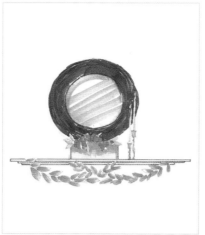
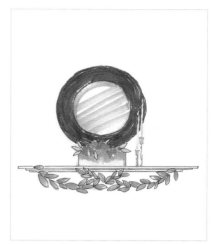

15/ Color in the mirror using a light gray (C0). Using the broad tip, start from one direction and glide to the opposite side. Pull the marker off the paper before starting the next stroke. Do not zigzag the pattern. Leave some white on the mirror to show a reflective surface. Next, use the brush end and start at the left of the mantel, gliding the marker to the right. Use the ruler to stay within the lines. Because our objects are 3D, they cast a shadow on the wall. Using the brush end, outline the left side of the mirror, around the leaves, down the outer box, mantel, and around the outer leaves on the garland. Then, outline the left side of the candlestick.

TIP: Depending on the direction of light, add shadow to the opposite side.

16/ Add a slightly darker shade of gray (C2) to the mirror. Use the broad tip, laying the tip flat on the paper, outline the top left around the circular frame. Next, in a diagonal pattern and at 45 degrees, draw your stroke in one direction, making sure to lift completely off the paper before you start the next stroke.

Now we are ready to outline the sketch! Start with the black detail pen (01) to outline the edge. Use your ruler to outline the mantel, working from top to bottom and filling in the sides. Next, draw a line down the left side of the floral arrangement and then on the right side.

17/ Continue to outline the leaves and garland. Work through each leaf with a half curve and complete the other curve of the leaf. Make sure that each leaf has its own shape and size so they do not look identical. Finish outlining the leaves in the arrangement.

18/ Continue to outline the mirror first and then move to the inner circle, working as swiftly as possible. With speed, your line becomes smoother and you actually have more control.

TIP: Practice your circles on a separate piece of paper. Once you feel comfortable and have a consistent shape, move over to your sketchbook.

19/ Using a fine detail pen (005) fill in the details of the mirror by adding more lines around the inner circle. Don't be afraid to have the lines overlap. And don't worry too much about making everything 100% perfect; I think the imperfections are what give it character!

Next, outline the pumpkins, starting with the center oval and adding the ears on each side. Then outline the stem of the pumpkin and autumn leaves. Don't forget to add center veins on the leaves. To add texture to the floral arrangement, add curlycues and squiggles to the arrangement. Outline the candlesticks first, then the tapered candles, and lastly, the flame.

Still using your fine detail pen (005), add a few loopier curlycues to each end of the floral arrangement. Next, add center veins to all the leaves on the mantel. Adding this detail makes the sketch come to life!

20/ Lastly, choose a thick black detail pen (008) to fill in the candlesticks. Leave a highlight on the right side of the candlestick to show the tan color peeking through. There you have it, a great autumn festive mantel to celebrate the fall season. Get inspired to try sketching a different season's décor on the mantel, if you'd like!

VI. CELEBRATIONS ARE MEANT TO BE SKETCHED

Applying All You've Learned to Events

There's always a reason to celebrate, and often that comes in the form of going over-the-top with décor, flowers, food, and drink. There's a deep appreciation when I gather with friends and family over the holidays and milestones in my life. I love that sketching can help capture those events. I've included a few lessons you can practice with: a birthday party scene, a holiday scene, and a dinner party with friends. The beauty here is that there are lots of other celebrations you can create a sketch for, so don't limit yourself; take the lessons here and create a sketch for your next celebration!

BIRTHDAY FUN

When I think of birthdays, I think of balloons, party hats, and desserts. Celebrating little birthdays are so much fun, and I wanted to think of something that reminds me of what I would have wanted my birthdays to be. Whether you're 1 or 81, birthdays are always worth celebrating! For your next birthday bash, why not make your own handmade invitations? Use the next lesson to inspire your next birthday bash invites!

MATERIALS

- 8½ x 11-inch (21.6 x 28-cm) paper/sketch-book or 5 x 7-inch (12.5 x 18-cm) notecard
- Mechanical or #2 pencil
- Kneaded eraser
- Clear ruler
- Black detail pen 01/02

SUGGESTED COPIC MARKERS

YELLOW

YG00 Y17

PINK

RV42 R22

GREEN

G82 G14 YG63

GRAY

C0 N4

BLUE

B12

1/ Start by drawing a 4-inch (10.2-cm) baseline and a 5-inch (12.7-cm) midline.

Draw a 4-inch-wide by 2½-inch-tall (10.2 x 6.4-cm) box centered on the midline. Draw three boxes in the center to represent the placement of the dessert stands. The tallest and center boxes measure 1 inch wide by 1¼ inches tall (2.5 x 3.2 cm). The box on the right measures ¾ inch wide by ⅜ inch tall (1.9 x 1 cm) and is ½ inch (1.3 cm) away from the centerline. The left box is ¼ inch (0.6 cm) to the left of the centerline and measures 1 inch wide by ½ inch tall (2.5 x 1.3 cm).

2/ Draw thin lines for the tops of your cake stands. Starting with the center box, find the halfway point, about ⅝ inch (1.6 cm) from the top of the table. Draw two horizontal lines for your center stand ¹⁄₁₆ inch (0.2 cm) apart. On the top of the right and left boxes, draw a thin horizontal line, no more than ¹⁄₁₆ inch (0.2 cm) apart. Continue to draw a ¹⁄₁₆-inch (0.2-cm) horizontal line below the top of the table box. Draw a line at ½ inch (1.3 cm) above the base of the box.

Add two tall boxes on the left and right side; this is where the party hats will stack! The left box measures ½ inch wide by 2 inches tall (1.3 x 5.1 cm). The right box measures ½ inch wide by 1½ inches tall (1.3 x 3.8 cm). Add centerlines to each of the hat frames, including the cake stand frames.

3/ Next, add an "S" curve on the left side of your dessert station. This will help when adding our balloons. The "S" curve should start at the base of the left hats and stop at the base of the table. Make sure that you don't go past the baseline, as this is where the floor stops. Start your right-side backward "S" curve 2½ inches (6.4 cm) above the center cake top, curving about 5 inches (12.7 cm) down the right side of the dessert table. Gently rotate the curve so it comes in about ½ inch (1.3 cm) away from the dessert table. Finish off the tail at an angle. You'll want to move at a fast enough speed where you can create one solid line.

TIP: Practice the "S" curves on a separate piece of paper until you can create one continuous and smooth line before sketching them on the actual sketch.

4/ Let's add our balloons for the balloon arch! Add in circles of different sizes; make sure to change them up! Add circles ranging anywhere from a ¾-inch (1.9-cm) diameter to a ¼-inch (0.6-cm) diameter. Some of the balloons can overlap, and some can touch side by side. Alternating the sizes of the balloons in the pattern is good. Find a pattern that works well for you!

Add our drawers! Add in boxes evenly spaced on the left and right side of the centerlines. Using your ruler, add a drawer measuring 1⅞ inches wide by ¼ inch tall (4.8 x 0.6 cm) on each side of the centerline. Start the drawer roughly ⅛ inch (0.3 cm) away from the center-line.

Next, at ⅛ inch (0.1 cm) left from the centerline, draw a ⅞-inch wide x 1½-inch tall (2.2 x 3.8-cm) box, making sure the edge is aligned with the first left edge of the top drawer. Then, draw a ¾-inch-wide x 1½-inch-tall (1.9 x 3.8-cm) box with about 1/16-inch (0.2-cm) space all the way around. Next, repeat the same steps on the right side, mirroring the left set of boxes.

5/ Add party hats on the right side by drawing in triangles stacked on top of each other. Round out the base of the triangles with a curve, continuing down the box until it is filled with hats. Add in the party hats on the left side of the table, using the same method.

For the handles on the long drawers, think of it as a smiley face with two dots on the ends. Add small circles for the knobs.

Add a fluffy ball at the top of each hat by drawing jagged edges in a circular pattern. Draw your cake stands (use the cake stand lesson on page 150 as a reference if needed). Be creative here and create your own shaped cake stands.

For the desserts on the cake stand tops, add milk glasses by drawing tall trapezoids or rectangles that taper in as you move toward the base. Create cupcakes by starting with small trapezoids and adding curves on the tops.

Move to the center cake and add the banner. Starting with a "U" curve, begin at the corner of the cake and finish at the next corner. Add upside-down triangles on the curve. Draw a number "1" on top of the cake. Use the centerline to keep the number centered.

6/ Add the legs of your dessert table and small detail in the center of your table. Start the left leg by drawing a diagonal line; a small circle; a quick zigzag; then a circle; dash line; then a circle. Continue this pattern on the right side of the legs. Then, at the bottom center of the dessert table, there is a small detail. Start about ¼ inch (0.6 cm) to the left of the centerline and create a bumpy curve. As you get to the center, draw a flat "U" shape and try to mirror the bumpy curve on the right side.

Add large leaves and florals in between your balloon arch. Alternate the curves of the leaves so that they turn in different directions. There is a combination of fern leaves and tropical leaves. For the fern leaves, draw a curve and add long rounded leaf patterns on each side of the stem. For the tropical leaves, draw a curve and jagged edges. Add daisy petals in between some of the balloons. I added four flowers; don't go overboard as you just want to hint at the florals. The main focus is on the balloons, while the leaves and flowers are accents.

Erase all your guidelines, leaving behind only what you want to color. Use your kneaded eraser to pull off the dark or heavy lines, leaving behind a light sketch.

7/ Now we're ready to color! Start by choosing two shades for each combination of the balloons.

For my yellows, I chose a light (YG00) and midtone (Y17). For my light pinks, I used a light (RV42) and darker tone (R22). When coloring, try not to put balloons of the color next to each other to create more of a random pattern. Color in using the brush end of the marker, following the shape of the balloon. The second tone of color is to show shadowing, so color in a crescent shape on the left side of the balloons and where the balloons overlap.

TIP: On the first side, leave a little white space to show a reflective surface on the balloon.

8 / Now to color our leaves, use the lightest green (G82). Start coloring from the base of the leaves and feathering out toward the tip. Leave a little bit of white on the leaves to show highlights.

With the midtone green (G14), add shading to all the leaves, and color in the whimsical details throughout the sketch. With the tip of the marker, stipple in the pompom on the hat. Add polka dots on two of the hats, color in the triangle in the banner, and color in a diagonal line pattern on another hat. Feel free to get creative here by creating your own pattern.

Next, use a darker green (YG63) to shade in and show the darker shadows in the leaves. In a feather-like motion, start from the base of the leaves and glide your marker toward the tip of the leaves, not quite reaching the very tips so all the tones show through.

9 / Time to add shade to all of our white objects. Since there isn't a white marker, we need to show shadows using a light gray color. We'll go over where I place the color so you can follow along! Using a light gray (C0) and the brush end, outline the left side of the white balloons. We are imagining that the light source is coming from the right side of the image. Outline the outer two edges of each drawer and cabinets. Also add a little line underneath our table legs. Outline a crescent shape underneath the knobs. Color in the left side of the cake stands and create an "L" shape on the cake.

Using a light shade of pink (RV42), color in the florals and add more whimsical details to our party hats. Color the tops of the cupcakes, triangle flag, the number "1" on our cake topper, and some of the party hats. Using the tip of the marker, draw thin diagonal lines for the party hats.

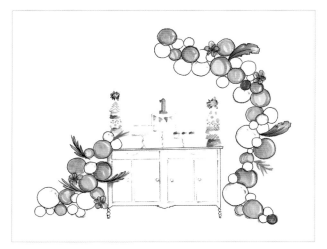

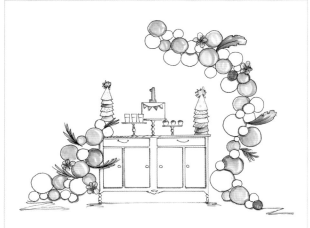

10/ Add in more fun touches! Using a light blue (B12), color in polka dots on the hat, stipple in the pompom, and fill in the left sides of some of the party hats. Continue with a light shade of yellow (YG00) and layer on a midtone yellow (Y17) to the hats and the triangle banner on the cake. Add the midtone pink (R22) on the left side of the number "1" cake topper and the cupcake.

Now for my favorite part, outlining and adding our finishing touches! When outlining, start from the outside in and work on the larger object(s) first. Using the 02 black detail pen, start outlining the table. Using your ruler and with medium pressure, hold a steady hand and start at the top of the table and work your way down to the legs. Next, outline the circles for the balloons. Then outline the leaves and center veins, and lastly outline the flowers.

> **TIP:** Typically each 3D object should have a light, midtone, and dark tone color. But for smaller areas, choose a light and a midtone to color each object.

11/ For delicate details, use a finer tip black detail pen (01). For all straight edges, make sure you are using your ruler. Make sure that after each step you air-dry the black pen by blowing on the area so you're not smearing the black ink. Start with outlining the cake stands, cake, and then desserts. Next, outline the pompoms and party hats. Next, draw in the centers of the flowers or add more veins inside the petals of the flowers. Then, using the ruler, outline the drawers and cabinets. The last detail to add would be the circle doorknobs and the curved handle pulls.

Our final step is to add dark tone shadows! With a dark gray (N4) marker and using the brush end, outline the white balloons where they overlap other balloons. Draw a zigzag underneath the right and left side of the balloons. Using the ruler, outline the edge of the drawers and two sides of the cabinets. Outline the left side of the cake and cake stands. Add a horizontal line under the buffet station to show a floor or ground that the furniture piece is sitting on. Add a zigzag on the right and left side of the buffet table, and your fun birthday scene is now complete!

HAPPY HOLIDAYS

The holidays are what I look forward to all year long, and one of my favorites is Christmas. I've always loved seeing the beautiful gift-wrapped presents along with all the twinkle lights on the Christmas tree. And of course, champagne to celebrate! 'Tis the season of giving, so why not create your own custom Christmas cards this year? By adding a festive element such as a bar cart, this might just be the right touch to make your holiday cards stand out this year.

MATERIALS

- 8½ x 11-inch (21.6 x 28-cm) paper/sketch-book or 5 x 7-inch (12.5 x 18-cm) notecard
- Mechanical or #2 pencil
- Kneaded eraser
- Clear ruler
- Black detail pen 01/005
- Gold gel pen
- White color pencil or white gel pen

SUGGESTED COPIC MARKERS

GREEN

YG23 G07 G99

RED

R14 R27

TAN/BROWN

E31

GRAY

C2

BLACK

100

1/ Start with your paper set up in a landscape orientation. Draw the baseline 2 inches (5.1 cm) up from the bottom of the sheet that extends across the length of the entire page. Find the midpoint of that line, and draw a 5½-inch (14-cm) vertical line from that point.

Next, 1 inch left of the centerline, draw a 1-inch-wide by 1-inch-tall (2.5 x 2.5-cm) box. Find the center of that box and draw a vertical line that is 4¾ inches (12.1 cm) high.

2/ First, we'll form the frame of our Christmas tree to the left of the midpoint. Start at the top of the line. Draw a triangle that is 1 inch (2.5 cm) high and has a 1-inch (2.5-cm) wide base. Move down the line ¼ inch (0.6 cm), and draw your next triangle. This triangle is 1 inch (2.5 cm) high and has a 2-inch (5.1-cm) wide base. Move down the line ⅛ inch (0.3 cm), and draw the third triangle. This triangle is ¾ inch (1.9 cm) high and has a 2-inch (5.1-cm) base. Lastly, draw two diagonal lines that extend out from the centerline of the tree.

3/ Now to put some ornaments on the tree! Draw circles that have a ¼-inch (0.6-cm) diameter. You have some freedom on where you place them, but you should have balance. For example, you should have fewer ornaments at the top and bottom of the tree than you have in the middle. Also, while the placement does not have to be symmetrical, you should have the same amount of ornaments on either side of the centerline of the tree. If you choose to have an odd number, then you should draw some ornaments on the centerline.

4 / Next, we'll frame out the bar cart. Draw a box ⅛ inch (0.3 cm) to the right of the midline, measuring 2½ inches wide by 1¾ inches tall (6.4 x 4.4 cm). Draw a vertical line along the center of the box.

5 / Now, ⅛ inch (0.3 cm) below the top of the box, draw a horizontal line. This will form the top of the cart. The legs of the cart will be a set of vertical lines. Start on the left leg, ⅝ inch (1.6 cm) from the centerline of the box, draw two vertical lines that are ⅛ inch (0.3 cm) apart. The right leg will be ¾ inch (1.9 cm) from the centerline of the box. Again, draw two vertical lines that are ⅛ inch (0.3 cm) apart.

Next, draw the bottom shelf of the cart. Then, ⅜ inch (1 cm) up from the bottom of the box, draw a horizontal line. Draw another horizontal line just above the previous one that is ⅛ inch (0.3 cm) away. Finally, draw the handle of the cart. This is a set of diagonal lines ⅛ inch (0.3 cm) apart that follow a 45-degree angle. Round off the edges of the top of the cart and the bottom shelf.

6 / The big wheel of the cart is on the bottom right of the box. Keep in mind that the bottom shelf of the cart will extend just past the wheel. So, frame the wheel out by drawing a 1-inch-wide by 1-inch-tall (2.5 x 2.5-cm) box that has a center where the right leg of the cart and bottom shelf intersects. Draw a circle in that box with a 1-inch (2.5-cm) diameter. Draw an inner circle that has a ¾-inch (1.9-cm) diameter. The smaller wheel is on the left side of the cart and will be at the bottom of the left leg. The circle you draw for that wheel should have a diameter of ³⁄₁₆ inch (0.5 cm).

7 / To decorate the cart, start with the presents. These are a series of rectangles. Similar to the ornaments, you have some freedom on where you place them, but don't overcrowd. Start with any presents that will be on the shelf of the cart and end with those on the top. Decorate the presents with ribbons and bows. The ribbons are two vertical lines ⅛ inch (0.3 cm) apart. The bows are two triangles that have points at the center of each gift box.

8/ Other items in the cart are wine bottles, a drinking glass, and an ice bucket. The first wine bottle will be to the right of the centerline. Frame it out with a rectangle that has a ½-inch (1.3-cm) base and is 1¼ inches (3.2 cm) high. Draw a vertical line down the center of this box. Starting from the top of this box, draw lines that curve out from the center. They start off narrow and get wider at the bottom. Place the drinking glass next to this wine bottle. It should be hexagonal in shape and near the main centerline of the cart.

9/ The second wine bottle will be in the ice bucket. Starting with the bucket, frame it with a box that has a ¾-inch (1.9-cm) base and is 1 inch (2.5 cm) high. Draw this box ¼ inch (0.6 cm) to the left of the cart's centerline. The ice bucket has a narrower base that is ⅝ inch (1.6 cm) wide. So, draw diagonal lines that start at the top of the box and come in toward the center. The wine bottle sits at an angle in the ice bucket. Freehand this bottle, making sure it comes up at a 45-degree angle and is roughly 1 inch (2.5 cm) long. Show that each wine bottle has a label by drawing curved lines below the bottlenecks.

10/ Now onto the final details. The cart has a narrow railing on the top. There is a banner hanging above and the planter of the tree tapers in. Start with the railing by drawing a box centered on the cart; it has a 2½-inch (6.4-cm) base and is ⅛ inch (0.3 cm) high.

The banner is also centered on the cart. From the top of the bar cart railing, extend the cart's centerline up 2½ inches (6.4 cm). At the top draw a 3-inch (7.6-cm) horizontal line across the top, forming a "T" shape. Next, draw a curved line to form the banner.

Finally, the bottom of the planter has a slight taper. The base should be ⅞ inch (2.2 cm) long.

11/ The "HAPPY HOLIDAYS" on the banner is written in all capital letters. The tops of each letter should be at the curved line you just drew. Use the center of the "T" shape to guide you; "HAPPY" to the left, "HOLIDAYS" to the right. Try to space the letters on the banner evenly.

12/ Now that you have all the details of your sketch, erase the guidelines using a point on the kneaded eraser. Remember that the more you erase in this step the better, since the markers set in the pencil lines and will be difficult to erase once the markers are layered on. Lastly, before you apply color, use your kneaded eraser to pull off the dark graphite pencil lines, leaving behind a light sketch.

13/ Now we're ready to color! Start with the lightest shade of green (YG23). Using the brush end and stipple effect (see page 149, Resources) to fill in the Christmas tree. Notice that the pencil marks are still visible as this helps to guide where you place color. Follow the diagonal lines and try to stipple along the lines, filling moderately throughout the tree. Vary the stipple sizes and move at a semi-rapid pace. Leave a little bit of white space to add the next several shades. Also, do not stipple over the ornaments, as you will later fill in with red.

TIP: Always start with the lightest shade and gradually lay down the next shade. Then continue with darker colors on top.

14/ Using the same stippling technique, choose a few darker shades of green (G07) and stipple in more filler into the tree. Don't worry about the pencil lines; as you add darker shades the pencil marks will blend in.

15/ Choose an earthy green (G07) to fill more of the tree, to show more of the shadow on the tree, and to coordinate with the colors of the presents on the bar cart. Depending on your preferred tree style, you can fill out more of the tree so it looks full, or less if you like your tree more slender and bare. Keep stippling, pausing and considering your artwork to see if you should add more or leave it alone. For the gifts, get creative! I drew diagonal stripes and polka dots using the brush end of the marker. The less pressure you apply, the thinner the line. Color in the wine bottles by outlining the label and coloring in to fill. Leave a bit of white space to show highlight.

16/ Choose a dark green (G99) to fill in the shadows on the tree. Notice the stippling is not as heavily filled as the other tones; you only want a hint of shadow versus overpowering the whole tree with the dark tones. Next, use the same brush end to fill in the wine bottle. Layer over the first color (G07) but allow some of the first color to peek through as well, leaving the white space for the highlight.

17/ Color in the ornaments and presents in red (R14), starting with the lightest shade first. Using the brush end, color each ornament in a circular motion, leaving a hint of white for the highlights. Don't worry about making the ornaments identical; we want a little bit of imperfection in each ornament. Next, outline the red presents to create a boundary. This helps you to stay in the lines when you fill in the presents.

18/ Fill in the presents with the same red (R14); use consistent motions and start from the top down. Use a slightly darker shade of red (R27) and shade in on the left side of the presents. I colored in a rounded corner on one side of the flat ribbon to show a shadow line. Leave a bit of white on the right side. Then, fill in a crescent shape on all the ornaments. This shows a midtone shadow and gives the ornament a 3D effect.

TIP: If you forget to leave white highlight or color over the whole shapes, you can add white highlights a few different ways: 1) using a white color pencil or 2) using a white gel pen.

19/ I wanted this bar cart to have gold shimmer, which we'll color in at the very end. To create a base layer on the bar cart, choose light tan (E31) and use the brush end to color in the entire bar cart, wheel spokes and the tops and bottoms of the wine bottle. Then, outline the "HAPPY HOLIDAYS" banner with the tip of the brush end marker. To color the glass goblet, use a light blue (B000) and color in the glass. Leave a little bit of white on the right side to show highlight.

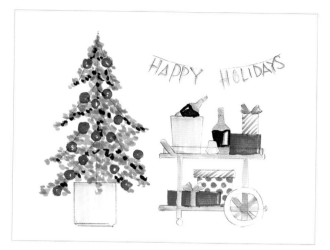
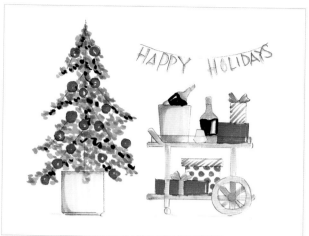

20/ Now color in the ice bucket and tree container. Use a light gray (C2) to color in the ice bucket. Start from the top down to the base of the ice bucket using the broad side of the marker. Leave a bit of white highlight on the right side of the bucket. Then, color in the Christmas tree container in the same manner, top to bottom. Make sure to glide the marker down the page and pull off as you get to the base. Leave a little bit of white space on the right side to show highlight.

21/ Next, we'll continue to use the light gray (C2) to color in the large wheel and the smaller wheel on the left. Color in a circular motion using the brush end. Then, letting the first layer air dry, go over the ice bucket with the same light gray (C2) for a darkening shadow. Color a horizontal band from the top of the ice bucket and then curving down the side of the bucket to show a shadow effect. Next, using the broad end of the marker color from left to right at the base of the ice bucket to show another area of shadow. Then, on the Christmas tree container, color in the left side in a curved "L" shape and outline the outer leaves that extend over the planter. Lastly, add an "S" curve or zigzag on the edges of the planter and the bar cart wheels.

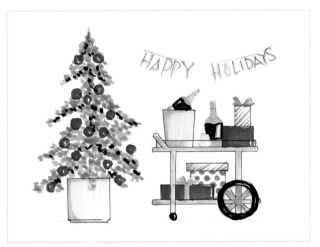 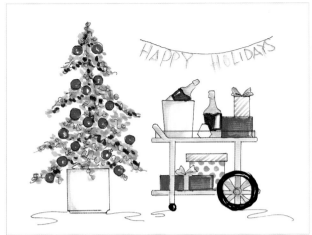

22/ Using black marker (100), carefully color in the wheel. Breathe through this step and don't worry about perfection! Color in a circular pattern and color in both the large and small wheel.

Now grab your black detail pen (01) and ruler to outline all the straight edges starting with the Christmas planter. Move slowly through each step and be careful not to smear the black. Next, outline the bar cart and wheel spokes.

23/ Take a finer tip black detail pen (005) and outline the textures on the Christmas tree. Start by adding squiggly lines and curlycues throughout the tree; move quickly. This adds texture and hides the pencil lines drawn earlier. Then, outline all the ornaments by drawing circles. Next, freehand the wine bottles, wine bottle labels, and wine glass. Outline the bows on the presents. Add a little hook on each side of the bow to show a bend in them. Add a spiral for the inside of the wheel.

Using the same pen (005), outline the "S" curve and zigzags at the ends of the planter and bar cart. The outline should match the gray shadow line. Next, add diagonal lines at the base of the Christmas planter for added texture. Lastly, add the curve outline for the banner.

24/ I like to add all the shimmer in the final step. Use a ruler for all straight edges and outline the entire bar cart with the gold gel pen. Next, fill in with the gel pen and leave a bit of the base color peeking through. Outline the bar cart's railing. Outline and fill the wine bottles, leaving a bit of negative space for the highlight. Next, color in the bows on the presents. You can even create a line and add loops in a semi-circle to embellish one of the presents. Then, outline the thickness of the "HAPPY HOLIDAYS" banner. Add dots where the string meets the letters to represent the holes that attach the words to the string. Then, add squiggly lines and curlycues to the Christmas tree for pizzazz! Draw and fill in a star on top of the tree.

25/ Adding little details personalizes your final sketch. Using (005) black detail pen, draw squiggly lines on the wine bottle to show writing. Then outline half of the dots on the "HAPPY HOLIDAYS" banner to show depth and a shadow line. Lastly, using a white colored pencil, add highlights if you missed any of the above steps such as drawing in a line at the right edge of the red presents. Add highlight to the green part of the wine bottle and bows on the presents. I even added curved lines on the black wheel. And there you have it, a festive holiday party sketch ready to send to your family and friends.

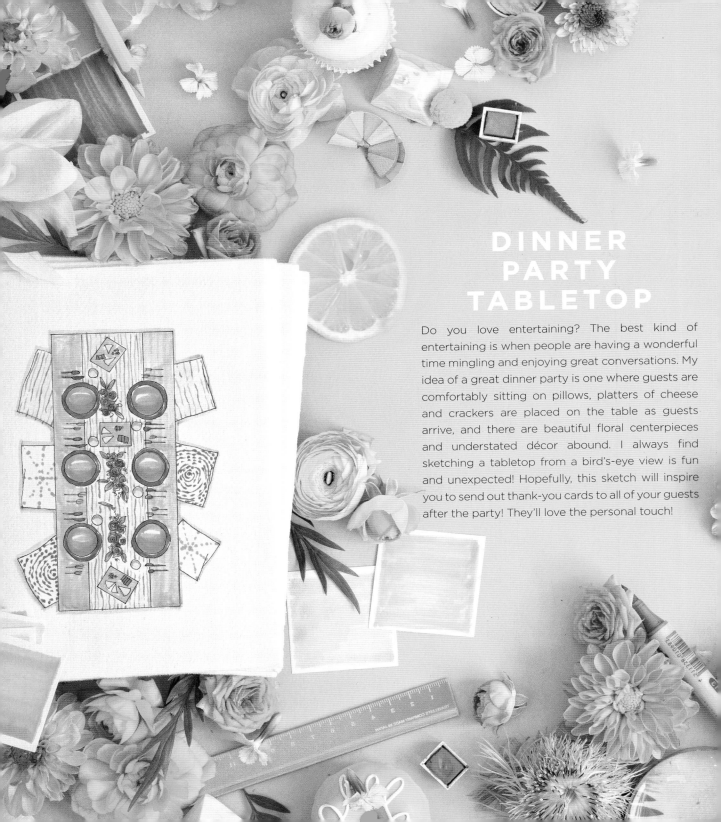

DINNER PARTY TABLETOP

Do you love entertaining? The best kind of entertaining is when people are having a wonderful time mingling and enjoying great conversations. My idea of a great dinner party is one where guests are comfortably sitting on pillows, platters of cheese and crackers are placed on the table as guests arrive, and there are beautiful floral centerpieces and understated décor abound. I always find sketching a tabletop from a bird's-eye view is fun and unexpected! Hopefully, this sketch will inspire you to send out thank-you cards to all of your guests after the party! They'll love the personal touch!

MATERIALS

- 8½ x 11-inch (21.6 x 28-cm) paper/sketch-book or 5 x 7-inch (12.5 x 18-cm) notecard
- Mechanical or #2 pencil
- Kneaded eraser
- Clear ruler
- Black detail pen 01/005
- Gold gel pen

SUGGESTED COPIC MARKERS

BLUE

BG000 B12 B23

PINK

R02

YELLOW/ORANGE

Y17 YR16 Y11

GRAY

N4 C0

GREEN

YG23 G82

TAN/BROWN

E31 E33

1/ We're looking at our table from a bird's-eye view! Start by turning the paper to portrait orientation. Using a mechanical pencil, in the center of your paper, start by drawing a long rectangle. Using your ruler, measure and draw in a 7-inch-wide by 3-inch-tall (17.8 x 7.6-cm) box. Remember to start with a light sketch so you can easily erase some of the markings before you color.

Divide the rectangle in half, lengthwise, and draw a vertical line down the center of the table.

Next divide each side into halves again. Measure ¾ inch (1.9 cm) and draw straight lines down the length of the table; this will become our table runner!

2/ For this seating arrangement, we'll be seating a table of six! Start with dinner chargers, measure 1¼ inches (3.2 cm) from the bottom of the table and begin drawing a 1-inch (2.5-cm) diameter circle. To ensure you have the circle evenly spaced, go ahead and measure 1¼ inch (3.2 cm) on the top of the table and begin to draw 1-inch (2.5-cm) circles. Lastly, add the center circles. You can be precise about where you position the center chargers, or you can "eyeball" the center and begin drawing in the chargers.

There is not one method to creating evenly spaced place settings. I do a mix of using a ruler and visually checking the distance or eyeballing to see if things line up properly.

3/ Next, we'll add pointed leaves to our centerpiece. Start by positioning a few leaves in the center of the table. Draw leaves in different directions and position them with enough space so that you can add roses. Add in center veins on your leaves.

Add in six swirls for roses, varying in size ranging with the largest no bigger than ⅜ inch (1 cm) and the smallest at a ¼ inch (0.6 cm) or a tad less (refer to page 152 in Resources for more details on drawing roses, if needed).

4/ Each pair of place settings will have a centerpiece, so add a grouping of roses between those sitting across from each other. Leave at least a 1-inch (2.5-cm) space between the next grouping as we will be adding cheese plates in the next few sections. Some rose groupings can be grouped into three roses and some can overlap in groups of two, while others are singled out. There is no right or wrong here.

Continue to add more leaves in different directions around the rose groupings. Add tiny circles as filler in the arrangements. This is to add textural elements so that there is interest.

5/ Next, draw in rectangles at different angles. Each box should not be any larger than 1 inch wide by ¾ inch tall (2.5 x 1.9 cm). Rotate each box in different directions. These will be our cheeseboards.

Then add one to three cheese slices by drawing what look like pizza slices or triangles on each cheese plate. To draw crackers, draw stacked rectangles or squares. Notice that the details are very small, so make sure you draw in the shapes using light pressure with either a mechanical or a finely sharpened pencil. Continue to draw small circles to represent nuts. Don't be too concerned with perfection here!

6 / Set the table by drawing utensils and wine glasses. To draw the forks, start with a "U" and draw a straight line down the center. The farthest fork from the charger will be slightly smaller. Add circles for the wine glasses to the right of each place setting. Since it is a casual party, we won't worry too much about the formal way to set a table!

7 / Next, add spoons on the far right side of each place setting by drawing an oval with a stem coming out of it. To draw the knife, which should be the closest to the charger, draw an elongated backward "P." Instead of making the loop look like a "P," drag the curve farther down the line to resemble a knife.

Then, draw a circle roughly ¾ inch (1.9 cm) sitting on top of the charger.

> **TIP:** To draw semi-perfect freehand circles, take your ruler and divide the charger in half. Draw a "C" on one side of the centerline and then mirror the other "C" to form a circle.

8 / Now to add floor pillows. Free-hand 6 squares in different angles around the table. The pillows should be near their corresponding place settings. Vary the sizes of the pillows ranging from 1-inch-wide by 1¼-inch-tall (2.5 x 3.2-cm) rectangles to 1¼-inch (3.2-cm) squares. Pillows can have what I call "cat ears," so they are not straight across the top; a line can cut into the pillow to show a bend in the pillow.

Next, take your kneaded eraser and erase the center grid line. Apply pressure to the kneaded eraser and pull off the extra graphite pencil from the page, leaving behind a light sketch. Erase the lines inside the plates.

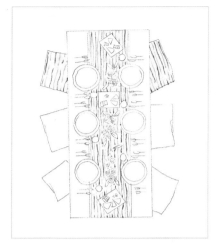
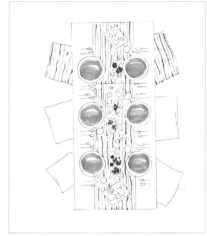
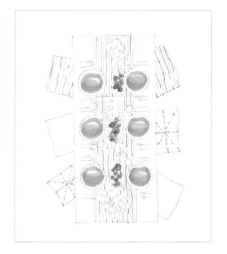

9/ Let's color in our pillows! Start with our lightest shade of blue (BG000). Using the brush end of your marker start coloring the runner, the farthest two pillows sitting across the table from each other, and the wine glasses. Using the brush end, outline the edges and start coloring in one direction.

Next, we will be adding stripes to the two pillows and runner. Using the brush end of B12, hold your marker with light pressure and add thin stripes to our runner and pillows. Lift off in some areas to leave a light trail and lines. This will be rough and not entirely smooth.

Next, using a darker shade of blue (B23), add stripes in between the first set of stripes. Lines can also be trailing lines and do not have to be continuous.

10/ Using our light pink (R02), color in the dinner plates, leaving a bit of white on the right side of the plates to show highlights. Color in the circle shape on the left side of the plate, making sure you lift off your color before you begin the next stroke. Try not to zigzag. Using the tip of your brush, stipple in color in a few of the roses in each of the entire grouping. Fight the urge to want to color every single rose in the centerpiece as we will be adding a different color later. Using the same pink (R02), add your midtones to the plates by coloring the left side of the plate in a crescent shape. By going over the top layer with the same color, this deepens the color, showing two tones in the plate. By being able to see two tones, this shows that the plate has depth.

11/ Next, using the same pink (R02), stipple in to fill more of the roses, adding more texture. Then create the alternate pillow pattern by drawing dots and dashes that intersect in the center of the pillow. To change the size of the dots, alternate between medium pressure and light pressure. Alternate the pillow pattern so that they are not directly across the table from each other.

Next, add in yellow (Y17) to the other roses. Stipple in the color and alternate between light and medium pressure as you apply color.

Adding a darker yellow-orange tone (YR16) to the roses will help add interest and dimension so they aren't flat. Using the tip of the brush end marker, apply color in a spiral pattern on top of the yellow roses.

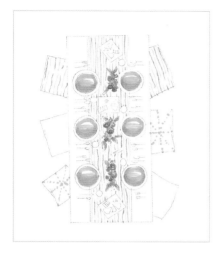

12/ Using a light pressure, color in the leaves with the lightest shade of green (YG23) as your base color. Start at the base of the leaf and use a feathered motion toward the tip of the leaves. Leave a bit of white on the leaves as a highlight. Next, add stippling as filler in areas between the pink and yellow/orange roses. This is to fill the gaps.

Now to add dimension to our leaves, add the second tone of green (G82) to the centers of the leaves. Start again at the base of a leaf and pull up in a feathered motion toward the tip of the leaf. Stipple in between the floral centerpieces.

13/ Now we're ready to color the wood on the table. Start by using the brush end of the marker (E31) to outline the table edge, part of the round charger that sits on the surface of the table, and edge table runner. Outlining these shapes first blocks the color so you can create a border to start coloring in the next step.

Since this is a large surface area, use the broad side of your marker. This is the side that has a flat chiseled end. Place the entire flat surface of the marker, starting at the left edge of the table and glide the marker across the entire table in one single stroke. Continue to color from left to right until the entire tabletop surface is colored in. Use the brush end to color the cheeseboards.

14/ Next, we'll be coloring the chargers, the circular pattern on the pillows, the spoon, and the knives. I wanted to have a dark charcoal color (N4) to color these elements. Using the brush end, color in each charger in a circular pattern. Next, fill in the spiral pattern on the pillows by using a dash line. Start in the center of the pillow and work in a clockwise direction. Then, for delicate details, use the very tip of the brush end to fill in the spoons and knives.

 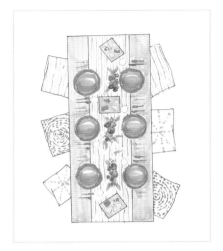

15/ Now color in the objects on the cheese platter. Use Y11 to color the cheese wedges and E33 to color in the crackers and nuts. For small details like these, it's okay to use one color.

16/ Time to outline! Use your black detail pen (01) and ruler to outline the table and runner. Be careful not to outline over the plates and silverware.

17/ Continue to outline the pillows, using a black detail pen (01). Notice how each pillow has its own unique characteristic and none are identical, although two patterns may repeat. Freehand each pillow and draw an angle into the pillow instead of straight across. This shows a little bend or fold in the pillow so that not all the pillows are square. We want the pillows to have a realistic touch since they are fabric pieces, so avoid using a ruler for the pillows. For our cheese plates, it's best to use a ruler. I like alternating between structured rulers with hand-drawn elements to give a balance between hard and soft surfaces.

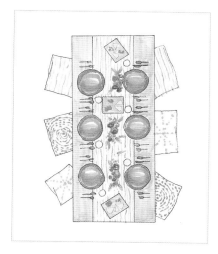
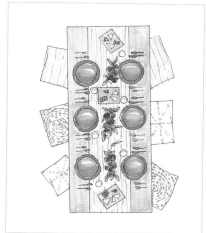
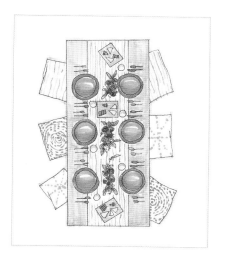

18/ Now for our delicate details! Choose a finer tip black detail pen (005) and begin to outline all the utensils. Start at one end of the table and move from left to right. Begin with the utensils, move on to the glassware by drawing a circle; then finish off by drawing the chargers and then finally the plates. Once you're done with one side of the table, flip the paper around to complete the other side of it. Try to keep steady and take your time through the finer details.

19/ Continue to add your black detail pen (005) detail to the roses, by starting in the centers. Draw in spiral shapes, making sure the centers are tight and open up as they come out to the outer edge. Next, outline the leaves and veins. To add textures, add squiggly lines and curlycues for filler or areas where there are gaps in the center-piece arrangements. Next, outline the cheese, crackers, and nuts on the cheese platter.

TIP: Don't worry if the marker spills over the outside of the lines. Make sure to take breaks in between so you can pull back and add elements if need be. Often, when you are too focused on one area or detail, you need to pull back far enough to see the whole composition.

20/ For the final detail, outline the entire outer pillow and table with a light gray (C0). This adds contour to the sketch! Angle the brush end of the marker to a 45-degree angle and outline the entire edge of the table and around the pillows. I think this would make such a fun party invite for your friends and family! I love adding personal touches to invitations. Feel free to make it your own by adding your own colors, tabletop décor, or different elements to the table that are reflective of your personal style. Have fun with it!

RESOURCES

Skill-Building Exercises and Drawing Techniques

WARMING UP

It's always a good idea to warm up your hands by starting out with a 10- to 15-minute freehand lesson, either by practicing different strokes/techniques or sketching an object that is in front of you. Be conscious of how you are holding your pencil; are you loosely or tightly gripping the pencil? Explore and experiment with different line weights, using the sharp and dull sides of the pencil (either a sketch pencil or mechanical pencil). Pay close attention to each movement. Having an understanding of your tools makes you a better artist.

STRETCHING

As important as anything else, sketching involves repetitious movements so before you begin, make sure to stretch. Take both hands, including your fingertips, and press them on the edge of your desk so that you are stretching your forearms. Next, rotate your wrists in circles, first in a clockwise motion and next in counterclockwise motion. Make sure to stretch before and after every lesson as you may find tightness or soreness in your arms and wrists after sketching for long periods of time.

DRAWING TEXTURES

Over the next few pages, I'd like to go over a few basic textures that we use in the book. Practicing these textures will give you a better understanding before you delve into each lesson. Practice a full line across your sketchpad for each texture example. These textures will add another layer of interest to your sketch.

STIPPLING

Stippling is referred to as marking your paper with small dots or specks. These stipples, or the stippling technique, are used to add more textures to flowers and areas that may have a lot of leaves. Hold your pencil 1 to 1½ inch (2.5 to 3.8 cm) away from the tip and in a rhythmic motion move only your wrist up and down to produce lots of dots on the page. Now angle your grip and hold the pencil at a 45-degree angle to see how the pencil mark changes the size and shape of the dots. After mastering these sketching techniques, you will begin to develop your own sketching style.

DIAGONAL SHORT LINES

Diagonal short lines are exactly as the name describes them. These marks are good for showing another layer of texture on 2D surfaces, such as on the edges of a cake stand or at the bottom of a buffet table. Drawing the lines closer together indicates more of a shadow on a surface. The more space you give the lines, the more you are indicating the light is touching the surface. Practice one continuous line starting with diagonal lines that are closer together, and gradually add more space between the diagonal lines.

SQUIGGLY LINES AND CURLYCUES

Squiggly lines and curlycues are random curls with random loops. I mostly use them in floral bouquets that show lots of textural flowers and leaves as well as bushes and topiaries. It's a fun and whimsical detail I add to my sketches and great filler for larger pieces. Practice looping in one direction and then start another by changing to the opposite direction; the more random and varying in size and direction, the better. Practice by making some with two loops and some with three loops.

ZIGZAG AND S CURVES

Zigzag and "S" curves are strokes I add at the ends of my objects. This is a stylized way I like to draw my flooring or ground beneath the object. It's a way that shows an object is on top of the floor or surface area. You will see me reference this technique toward the end of every lesson.

1/ Start with the "S" curve but have the "S" lay flat.

2/ Then, draw one line with a backwards "S" curve.

3/ Then draw a flattened out "Z."

4/ Lastly, draw a backwards "Z."

For practice and a quick guide on how to draw a cake and a cake stand, follow these steps. This 10-step guide can help you draw cakes faster as you start mastering the steps.

1/ Draw a 1-inch-wide × 1½-inch-tall (2.5 × 3.8-cm) box. This will help to frame out the cake you're about to draw.

2/ Next, divide the box in half. Using your ruler draw a vertical line exactly halfway through the box.

3/ Now divide the box in half horizontally at ¾ inch (1.9 cm). Using a ruler, draw a thin line underneath the first line, approximately ⅟₁₆ inch (0.2 cm) thick.

4/ To start drawing your cake stand stems, draw a curve on each side of the centerline, below the cake stand. Mirror the curve on the right side.

5/ For more detailed areas, take your mechanical pencil and draw smaller inverse curves on the left and right sides.

6/ The next shape is a bit trickier as you will imagine drawing an elongated backwards "S". Draw these shapes. Mirror the "S" shapes on the right side. Stay as close to the centerline as possible without touching it.

7/ Draw a small circle.

8/ For the last part of the stem, draw an elongated and angled "S" on the left side of the centerline. Mirror this shape on the right side of the centerline. Using your ruler, above the cake stand, come in about ⅟₁₆ inch (0.2 cm) on each side of the box frame, as this will be the edge of the cake.

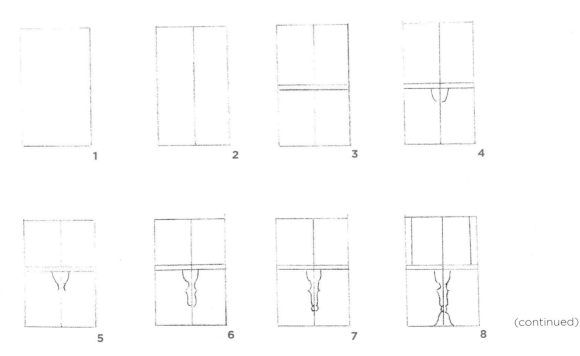

1　　　2　　　3　　　4

5　　　6　　　7　　　8

(continued)

9/ Now, to add a bit of texture to our cake. Add fluffy clouds to the top of the cake. Add a ¼-inch (0.6-cm) leaf and a center vein on the leaf.

10/ Draw horizontal lines along the stem of the cake stand to show details. Add a large teardrop shape to the top of your cake. The teardrop shape should be ½ inch (1.3 cm) in height. You'll want to keep in mind to sketch lightly. If you find that your pencil markings are too heavy, take the kneaded eraser, press your thumb into it and pull off the extra graphite.

Erase the bounding box, centerlines, and any cake corners that are covered by florals. For small detail areas that need erasing, mold the kneaded eraser to a fine point to erase unwanted marks.

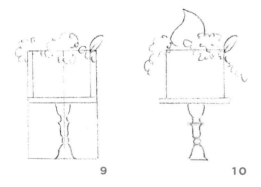

9 10

FLORAL TEXTURES AND PRACTICE DRILLS

Just as an athlete will warm up before a race or competition, so should artists and illustrators. These practice drills and floral textures are here to help loosen the muscles and get you in the creative zone. Learning how the pencil lines behave and what it produces will help you to rotate your pencil, tighten or loosen your grip, or know what to do to achieve the desired finish. The loops discussed here do not appear in any of the lessons in this book, but are intended to get you to loosen up as you delve into the floral drills.

LOOPS

Loosen your grip and see what shapes you can make with this loop drill.

See if you can control the size of your loops by drawing smaller loops.

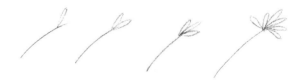

Using light pressure, draw up and down waves.

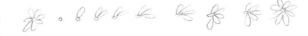

SIMPLE FLOWER

Start with a line and small leaf. Add another loop to form a leaf. Continue to add petals to create a full bloom.

SIMPLE DAISY

Start with a circle. Create a loop pattern to form a leaf, continue all the way around the circle until you've completed the full rotation.

SIMPLE FLOWER

Draw a diagonal line. Start with a "V" pattern and draw jagged edges at the top. Continue the pattern until you've completed the full flower. Draw a solid circle and lines coming from the center to show details of your flower.

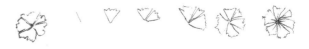

SIMPLE ROSE

Start with a small heart-shaped center. Add another small heart behind the first. Add a slightly larger petal and continue to add petal shapes in a circular pattern. As you build out the petals, continue to make them slightly larger than the first layer, eventually making the final outer petals larger to show the rose petals opening.

SIMPLIFIED ROSE

Start with a small spiral for the center. Continue to loop around for two rotations. Then add half-curves to show your rose petals. Vary the shape and size of your petals; continue to move in a circular pattern. As you come further out to the edge, enlarge the petal so you can start to see the rose open up. Remember, stay tight in the center and as you come out from the center, gradually enlarge your petals.

RUFFLED ROSE

Start with a more angular spiral center. Continue to add more jagged edges as you add petals to your rose. The more jagged the edges, the more ruffles your rose will have. Hold your pencil with a loose grip for more control.

SIMPLE ANEMONE

Start with a small line. Create a "V" pattern and add jagged edges to the top of the petal. Create four petals. The last shape is a rounded base with jagged top. The angle you are drawing makes it look like it's turned slightly off center. Darken the center by shading in the middle. Add a single line through each petal to show the vein in the flower.

SIMPLE POPPY

Create a simple petal. Add a petal behind the first. Next, add a petal in the background. Add your stem. Add leaves to both sides of the stem. Add veins in the center of your leaves and floral petals.

PRETTY DAHLIA

Create a curve. Complete the opposite curve to form a single petal. Add more petals and finish off the florals.

LEAVES LESSON

It's always good to have basic foundational skills before you begin to sketch. Having an understanding of basic shapes and how to create them will help to work through any challenges you may face in this book. Often, breaking down each element step-by-step and practicing one element of an overall larger object helps to focus your ability to master a technique. Also, learning how to draw the basic shapes will help you to sketch faster and more accurately. Repetitive movements will help with muscle memory and make sketching a more enjoyable process. Let's practice our leaf shapes!

POINTED ONE SIDED LEAF

Start with a delicate curve. Start at the stem and draw a small curve. Finish off your leaf by creating another curve. Add more petals on your stem. Start with a larger leaf at the base of the stem and gradually reduce them, making the last leaf the smallest as you work your way to the tip of the stem.

POINTED DOUBLE SIDED LEAF

Start with a delicate curve, roughly 1 inch (2.5 cm) in length for the stem. Add pointed leaves to one side of the curve. Finish the other side of the stem by mirroring the leaf pattern. Add center veins to each leaf.

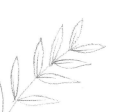

POINTED LEAF

Start with a large curve, roughly 1 inch (2.5 cm) in length. Complete the other side of your curve to close your leaf, starting at the tip and bringing the curve down the base of the leaf. Start from the outside of your leaf pattern and pull upward to create your center vein. Draw a whole line of leaves across the paper for more practice.

ROUNDED LEAF

Start at the base and pull into a rounded curve to form a more rounded leaf shape to create a loop. Next, start from the outside of the leaf and move upward to form a center vein. Practice one row across your paper and change directions for added practice.

ROUNDED LEAVES ON A STEM

Start with an underhand curve, 1 inch (2.5 cm) in length. Add your rounded leaves along the stem.

Mirror your leaf pattern on the other side of your stem. Add veins to your leaves.

TEXTURAL BRANCHES

Start with an underhand curve, 1 inch (2.5 cm) in length. With a loose grip of your pencil, add small circles on each side of your line. Then add small curlycues and squiggles.

POINTED LEAF ON A STEM

Draw a curve, 1½ inches (3.8 cm) in length. Add long pointed petals along the stem.

Mirror the long pointed petals on the right side. Starting from the stem, add center veins on all the petals.

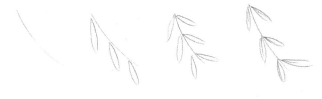

DIRECTION OF LIGHT

It's good to understand how lighting plays a role in creating highlights and shadows and how it casts shadows in your sketch.

As you practice the lessons throughout the book, decide what direction the light is coming from. Once you decide where the light is coming from, you can determine how to shadow your object, which adds a more dynamic and realistic view of your sketch. It's important to stay consistent with where the source of light is throughout your sketch. For example: if the light source is coming from the right side, always keep highlights on the right side of your object. Don't mix up directions within a single sketch, as it will look confusing. Size also determines where we might end up coloring. I've included examples of how to show highlight and shadows in different sized objects.

SCALE AND PROPORTION

Scale and proportion are references to size in relation to one another. In each lesson, either exact measurements are listed or loosely described. Scale and proportion have been predetermined for each lesson so that you can follow my exact steps, or as closely as possible, to achieve the results in the sketch lesson. Having an understanding of objects in relation to the human body will help with sketching your objects accurately. Once you have a good understanding of scale and proportion, it will be easier to sketch on your own.

In this example, when I'm thinking about scale & proportion, I find the smallest base measure, such as the orange planter, and the next size I draw is roughly double the size of the orange planter. The largest cactus plant is about three times the base measure.

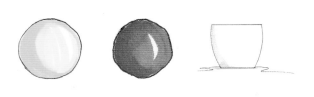

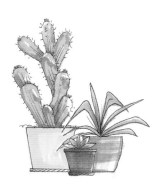

INSPIRATION SKETCHES

Sometimes, it's hard to come up with ideas on your own without a reference point or if there is a technique we didn't cover in the instructional part of the book. Feel free to use this section as a point of inspiration or to see how to create certain textures, shapes, or ideas to practice with. I've added a few inspired pieces for you to practice with.

ACKNOWLEDGMENTS

I am grateful to so many who have helped guide, shape, love, and support me through this journey.

First, I thank God, for without Him nothing is possible.

To my parents and family who raised me to work hard, to pray, and to believe. Without their sacrifices, I would not be here. To my mom and dad, who let me be creative, allowing me to spend hours drawing and exploring my creative talents.

To my amazingly patient husband, Chris, who is my rock, my best friend, the one who balances me, and reminds me to keep going. I love you with all of my heart.

To my sweet and amazing boys, Noah and Elijah, for being the best sons in the whole world. Coming home to their joy and laughter makes the journey so much sweeter.

To my mother-in-law, Rosa Junsay, for always being there to take care of our boys, feed us, and help us whenever we need her.

To my friends whose loyalty, positivity, support, and encouragement throughout my career, and especially during the writing of this book, helped me to finish strong.

To my past art teachers, Mrs. Yu and Mr. Klement, for instilling creativity into my childhood and being my earliest influencers. Art class would have never been the same without them.

To those who follow my work, have taken a class from me, and those I have yet to meet because of this journey—THANK YOU for supporting and buying this book.

To the incredible & talented vendor team that pulled together the styled images for this book, especially my dear friend Lucia Dinh Pador for her patience, incredible eye, and endless talent. I could not have done this without you.

CREATIVE DIRECTOR & STYLIST— Lucia Dinh Pador from Utterly Engaged

PHOTOGRAPHER— Lane Dittoe

FLORAL DESIGNER & STYLIST— Lizbeth Molina from Rawfinery

ASSISTANT— Danni Hong and Caroline Cervantes

CINEMATOGRAPHER—California Electric

PROPS—Found Rentals

CAKES & DESSERTS—Sweet Lee Made

CAKE TOPPER—Tammy Mendoza of Letters to You

MAKEUP & HAIR—e2beauty Hair & Makeup

WARDROBE—Morning Lavender

To my agent, Kimberly Bower, for guiding me through the process and helping me navigate the hard stuff.

Last but not least, to my publishing company, Page Street Publishing; my editor, Sarah; and the entire design team for being so open to my ideas, and for letting me have the creative freedom to turn a dream of writing a book into reality! To my copyeditor, Rochelle Arvizo, for her focus in making the words flow. And to the entire Page Street Publishing team whom I failed to mention, thank you for making this a dream come true!

ABOUT THE AUTHOR

Mary Phan has always been drawn to the arts. After beginning her career as an interior designer, dabbling in fashion, and staging model homes, Mary's love of creating an atmosphere and a feeling in the spaces she entered inspired her to launch an event planning and design company in 2008.

In addition to creating memorable experiences, Mary sent her clients home with physical mementos in the form of custom illustrations that became an indispensable part of her design process. In 2013, Mary took that love of illustration to the next level, launching The Sketchbook Series to help other event planners and designers learn a skill that had become a key way that she communicated with her clients. She has since rebranded to Very Mary Inspired where she empowers creatives—giving them tools, inspiration, and products to bring value to their lives and their creative businesses.

Although Mary no longer plans and designs events, she has become an impactful creative leader and has a passion for inspiring creatives everywhere.

Aside from traveling and teaching, Mary shares her adventurous days with her husband and two little boys located in the East Bay Area.

Mary has been featured in wedding blogs and magazines, *Utterly Engaged*, *Flutter Magazine*, The Knot, *Ceremony Magazine*, *Today's Bride*, Style Me Pretty, Green Wedding Shoes, California Wedding Day, and more. Mary has spoken and taught at many highly-regarded industry conferences and summits—Engage Summits, Oh So Inspired, LVL Academy, Fluerology, Outspire, APCWC, NACE, ILEA, and more.

KEEP IN TOUCH

 @thesketchbookseries
@verymaryinspired

verymaryinspired.com
thesketchbookseries.com

Mary Phan

INDEX